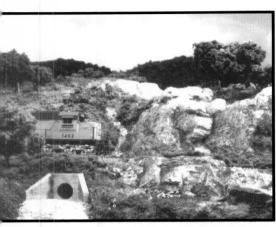

THE
SCENERY
MANUAL

Library of Congress Catalog Card Number:

93-61065

ISBN.........1-887436-00-6

CONTENTS

CHAPTER III

LANDSCAPE

CHAPTER IV

STRUCTURES AND DETAILING

CHAPTER V

DIVIDE AND CONQUER

INTRODUCTION

The purpose of this book is to help you add scenery to your model railroad. Your trains can run without scenery, your switches can work without it, but there is no realism without scenery. The setting and background that you create can give your trains a geographic location, a seasonal orientation, and a time era.

The principal idea we want to convey is that realistic scenery is within the scope of any model railroader, even those who do not consider themselves particularly talented in artistic fields. Lack of ideas on how to begin and fear of how complicated the job might be have left many otherwise excellent railroads in the "trains run, no scenery" category.

No matter what stage your railroad is in, you will find this book helpful. We begin with some general ideas on layout building, go on to planning scenery, and then move to specifics with the Woodland Scenics Terrain and Landscape Systems. Not only are the systems easy to use, but the products have been created to coordinate with and complement each other, producing realism without an artist doing the work.

We suggest that you read the entire book before you begin. The Scenery Manual will give you an overview of all of the ideas and products that make up the Woodland Scenics system, and allow you to select those which will be most useful for your particular situation. Then experiment. Because of the way the products have been formulated, it is almost impossible to make mistakes that are not easily correctable. We think you will be pleased with the results, as well as with your own creativity.

Even though the emphasis of this book is on model railroading, many other types of modelers will find the techniques and products described here as very useful. Whether you are a military modeler, a diorama builder, an architectural model maker, a dollhouse builder, or have a project for school, this book can help you. The basic techniques of creating terrain, covering it with landscape materials, and finishing it with details can be used by any kind of model builder. When you learn and practice these techniques, you can use them for any type of model you choose to build.

Chapter I
LAYOUT BASICS

RAILROAD PREMISE

When you build a model railroad, you are creating a miniature world of your own conception and design. Some of the excitement of model railroading is in building the towns and industries, and then designing the transportation network to keep them running. In a world where we often have little control over our surroundings, model railroading offers the opportunity to be in charge of the world, even down to the naming of railroads, towns, and businesses.

In general, there are two methods of modeling. One is to design a model railroad after some particular *prototype** (real railroad or location), and the second is to create an imaginary railroad. The choices you make constitute your *railroad premise*. Each method has its advantages and each offers a multitude of possibilities for scenery and *operation*. The methods can also be combined to use, for example, a real prototype railroad in a location that is imaginary or a real location with a railroad of your own creation. Model a railroad in your local area, a railroad you or someone you know has worked for, or a part of the country that is interesting to you. The choice is yours.

SCALE

Model railroads are generally built as *scale* railroads, that is, everything on the layout is built to a specific percentage of what it is in the real world. In

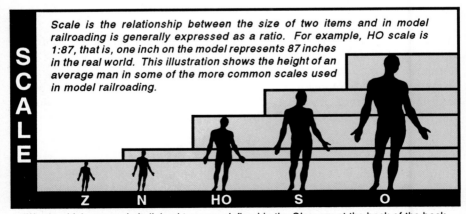

S
C
A
L
E

Scale is the relationship between the size of two items and in model railroading is generally expressed as a ratio. For example, HO scale is 1:87, that is, one inch on the model represents 87 inches in the real world. This illustration shows the height of an average man in some of the more common scales used in model railroading.

Z N HO S O

*Words which appear in italicized type are defined in the Glossary at the back of the book.

model railroading there are a number of common scales with engines ranging from small enough to hold in the palm of your hand up to those large enough to ride on. The selection of which scale to model in is entirely up to you. There are a number of items that can be considered before selecting a scale. These include the available space, how much railroad you want to work with, money available to put into the hobby, and where the railroad is to be located. Commercially available equipment, buildings, and detail items are more abundant in HO scale than in any other model railroading scale. According to the *National Model Railroad Association* (NMRA), 77% of their reporting membership models in HO scale and 12% in N scale. Each of the other available scales makes up less than 1% of the total. If you want the most abundant selection of ready to use items as well as kits and detail parts, it would be wise to select the more popular scales.

Many items of scenery have no real scale. Real world trees, bushes, grass, mountains, and streams all occur in a variety of sizes. The Woodland Scenics scenery materials can generally be used in any scale. Any Woodland Scenics product that is designed for a particular scale has that information listed on the product label.

GAUGE
Gauge in railroading terms refers to the distance between the *rails*. In 1886 a federal law was passed setting the *standard gauge* for railroads in the United States at 4'-8½". This standardization means that engines and cars from any railroad can run on the *track* of any other railroad. There were a few specialty railroads in the United States, some still in operation, which did not follow the standard gauge. They are known as *narrow gauge* because their rails are closer together than the standard gauge. Primarily, these were railroads that ran in mountainous areas where railroad construction problems made it more advantageous to use a narrower track, a tighter radius on curves, and the shorter engines and cars that this type of construction allowed. These railroads used a variety of specific gauges on their tracks, with 3' being one of the most common.

In model railroading it is possible to model in either standard gauge or narrow gauge. The National Model Railroad Association has developed standards for manufacturers that make the engines, *rolling stock*, and track you purchase interchangeable within each scale and gauge. Standard gauge equipment and track are available in all scales. Narrow gauge equipment and track have a greater availability in some scales than in others.

TIME ERA
At this point, you will probably want to give some thought to a time era you prefer. Some of the possibilities include early steam engine era, mid to late steam, transition to diesels, early diesel, current time, etc. No prototype

railroad would have engines and rolling stock from all these eras running at one time. Even if the railroad is an imaginary one, it is still difficult to try to include engines and rolling stock from every time era and make it believable. By selecting a time era it is possible to logically limit the equipment to what was available and running in that time period. A time era also helps in the selection of appropriate buildings and detail items.

T I M E	1831-1880	Early Steam
E R A	1881-1921	Middle Steam
	1922-1940	Late Steam
	1941-1960	Transition to Diesel
	1961-Present	Modern Diesel

GEOGRAPHIC LOCATION

In choosing a geographic location for the railroad, be as specific or as general as you want. It is permissible to choose to model a particular county in Colorado or an individual small town in Nebraska. But it is just as acceptable to model a representative New England town or a typical lumbering area of the Pacific Northwest. The extent of the geographic location you choose to model may be somewhat determined by the scale you model in and the size of layout you plan to build. Obviously, in the larger scales more actual space will be required to model a specific prototype area than in the smaller scales.

Modelers frequently talk about a concept known as *"selective compression"*. This means selecting to model representative items from an area because it is not really possible to put in every single item that exists there. For example, select two or three houses to put in a town rather than all the houses that really exist there. Model three or four industries that a railroad services or use a couple of mountains to represent all the mountains in a range. Selective compression makes it possible to put a fairly large amount of actual geography on a small layout.

Another consideration is the type of buildings and industries you plan to model. For example, are you interested in showing mining and the types of industries that grew up around it? Or is your interest in cities with large *rail yards*? These kinds of considerations can help in the selection of the geographic location for the railroad.

A SPACE FOR THE RAILROAD

Once some decisions are made about what kind of railroad is to be modeled and in what scale, the next step is to find or create a space for the railroad. There are many alternatives depending on space available, your interests, time, budget, and geographic location.

If this is your first layout or if the available space is small, consider building a *module*. A module is a small model that can be combined with other modules to make a large layout. In many areas of the country *modular groups* exist where each person builds only a small part of the layout, perhaps 2' by 6'. The modules are then put together to form a larger layout when the group meets. Joining a modular group may provide an opportunity to know and work with some experienced model railroaders. Sometimes these groups display their modular layout for railroad shows and conventions or in public displays at malls or other areas.

A larger personal layout can also be built using modules. Perhaps the resources are not available for a large layout now but will be in the future. Begin by building a module or two. Later on they will serve as the base for a larger railroad. One of the advantages of modules is that they can be built with removable legs for easy disassembling and storage. In the smaller scales, a module or two can be the entire railroad.

Another good choice for new modelers or small areas is to create your layout on a sheet of plywood, 4' by 8' or smaller. With a little planning and imagination, a lot of railroad can be built on a plywood sheet, even with some of the larger scales. If space is limited, this type of layout can be built so it can be stored when it is not being used.

The more ambitious modeler can consider using part of the basement, an extra bedroom, part of a garage, or an attic. Perhaps a separate train building can be constructed in the back yard, if money and space allow. Successful layouts have been recorded in such unlikely areas as wine cellars, utility rooms, former bomb shelters, and on shelves circling living rooms or bedrooms. Be creative! But by all means check this out with other family members before beginning to build.

TECH TIP

Before starting to build a large layout, you might want to use Mold-A-Scene Plaster to create a 1/4 or 1/8 scale model of the layout you plan to build. Strips of cardboard or string can represent the track. Shape the Mold-A-Scene to form the mountains, hills, and other terrain features. This modeling technique allows you to locate areas for particular geographic features, towns, and yards, and look at aisle clearances.

RAILROAD PLAN

After a decision has been made on where the railroad will be, the next step is to create a plan of what the railroad will look like. This may be a very elaborate scale drawing or just a rough idea. It should include at least a general concept of where track will be as well as locations for rail yards, towns, roads, and industries. Also include geographic features such as mountains or bodies of water.

The plan can and probably will be changed some after the building stage has begun. In many instances, particularly for beginning modelers, track, buildings, and scenery will take up more space than anticipated. Plan the track first, then work other items in around it. If there is some particular building or scenery item that you feel must be included, plan for it early, and know the size of the space which must be allowed.

BENCHWORK

To begin the actual building of the railroad, start with the *benchwork*. This is the understructure that holds up the roadbed, scenery materials, and wiring of the railroad. There are several possibilities for the benchwork depending on the type of railroad that is being built.

Perhaps the entire railroad is to be constructed on a sheet of plywood. In this case you might want to use lumber to build a supporting frame and legs for the plywood at whatever height is convenient. Or perhaps the plywood will sit on an existing table. The frame and legs or the table the plywood sits on will serve as the benchwork.

Modular groups will usually establish a plan of how every module is to be constructed so that it will coordinate with others in the group. This plan will probably specify the size and type of building material, as well as height and exactly how it is to be put together. These specifications must be followed to make it possible for all modules in the group to be combined into one large layout.

An individual module may or may not be planned for later inclusion in a larger layout. If it is to stand alone as the entire layout, decide whether the module will be taken down and stored at times. If so, foldable or removable legs under the frame may be desirable. A module that is to be part of a larger layout can be constructed with a supporting frame at whatever height is chosen for the entire layout. Lumber is probably the best material for the legs and frame of the benchwork.

For larger layouts, a more extensive benchwork is required. Before beginning, we suggest reading more about benchwork. Many model railroading books and magazines devote sections or articles to this aspect of the hobby. You

may also want to discuss benchwork with other model railroaders or your local hobby shop. The benchwork needs to be strong enough to support the railroad. It needs to be open enough to allow access to maintain and repair the railroad. And, it should help hide some construction features such as wiring.

TRACK

Track, of course, is a vital feature on any model railroad because it determines where the trains will go. There are many excellent books and magazine articles that will help in track planning. If this is your first railroad, try to keep the track plan fairly simple. It is always possible to expand it later on. If you have joined a modular group, be sure to check their module specifications for information on track. The group will probably dictate track distance from the front of the module, how the track is to be configured, track elevations, whether track is purchased assembled or hand laid, and the size of rail to be used.

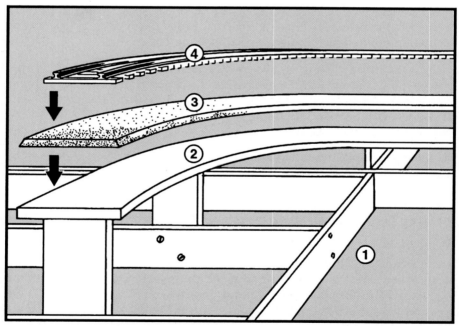

This illustration shows the layers of materials which make up the benchwork. 1. On the bottom is the open plywood benchwork usually seen with a large layout or a module. 2. The next layer is made up of risers and plywood strips which form the sub-roadbed. 3. On top of this is a layer of roadbed material which could be Woodland Scenics Track-Bed, cork, Homasote, or other material. The purpose of this layer is to deaden sound from the train engines. 4. The track is laid on top of the roadbed.

A real railroad is built to carry freight, passengers, or both from one place to another. In planning track for the layout, be sure to consider what the railroad will do. Think about how the railroad will provide service to local towns and industries, how it really or imaginatively connects with the larger world, and what kind of purpose it could have on the layout that is being built. Of course, other important items such as the radius of curves, *clearance* around planned geographical features, and a realistic look must also be kept in mind.

Track can be purchased ready-made, with ties and rail put together, or the ties and rail can be laid individually by hand. Obviously, purchasing it ready-made is the quickest and easiest way to get track down, and is preferred by most people. *Switches* can also be purchased ready-made which saves considerable time in laying track. It is generally easier to lay the track before completing the scenery.

The material that is put directly under the track is known as *roadbed*. Track must be securely fastened down to this material so that it does not move when the trains run. Keep in mind that train motors are noisy and that a proper roadbed material can help deaden their sound. Roadbed materials can include foam, cork, *cellular Styrofoam*®, *Homasote*®, Upsom Board®, and plywood. Be sure to look for a material that will absorb sound.

If the railroad is being built on a sheet of plywood, attach strips of roadbed material in the proper width for your scale directly onto the plywood and tack or glue the track to it. To add roadbed to open benchwork or to install elevated track above a plywood layout, cut strips of plywood or foam in the proper width for scale track. These strips are known as the sub-roadbed. See illustration on Page 18. Fasten the sub-roadbed strips to the benchwork where the track is to be located by supporting them with a series of risers which connect the two elements at the desired height. Finally, cover the sub-roadbed with roadbed material and lay the track.

WIRING

The wiring of a model railroad involves installing the electrical connections that will allow the trains to operate. There are a number of possibilities available here which are appropriate for different situations, different experience levels, and different budgets. We advise reading some books or articles, talking to some model railroaders, or checking your local hobby shop before making a decision. With a modular group, their specifications will detail how the module wiring is to be done. It is usually easier to have the track wiring complete before beginning scenery.

TERRAIN BASE

Depending on which type of contours you decide to build and on what type of layout you are building, there may be a need to add a *terrain* base. This is a temporary base which is added to the benchwork to contain and support some types of terrain building materials while the land contours are formed. A terrain base will be needed with newspaper wad construction but will not be needed with cardboard strips or screen wire. The material used for the terrain base can be Homasote, Styrofoam (see illustration on page 33), corrugated cardboard, or other similar material.

OPEN BENCHWORK LAYOUT

Risers

Cardboard

① ②

1. Depending on the type of terrain building materials used, this open benchwork might require a terrain base of corrugated cardboard, Styrofoam, or other material so that the terrain materials do not fall through while work is being completed. 2. Here the terrain base is in place and beginning terrain materials can be added to the layout.

If the layout is being built on a sheet of plywood, the plywood is the terrain base. Nothing more is needed. With open benchwork on a module or a larger layout, a terrain base must be attached if newspaper wad terrain material is used to prevent the material from falling through as you work. Attach the terrain base material directly to the benchwork. See Page 21.

A plywood sheet or module may also need some type of material attached to the back and sides of the sheet or module to contain newspaper wad terrain or to provide an attachment for cardboard strips. The top profile of this material may be contoured to represent rolling terrain.

It may be possible to use the walls of a layout room to help contain terrain materials. After the terrain phase of building is completed, it may be desirable to remove some of the terrain material and terrain base to provide easier access to track and wiring from below or behind the layout.

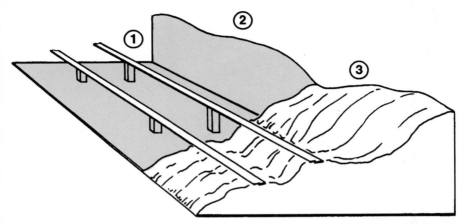

1. A sheet of plywood forms its own benchwork and terrain base on which to build a model railroad. The plywood can be set on a table, or a frame and legs can be built for it. 2. Attach contoured profile panels on the sides and back to contain the terrain materials while work is being completed. 3. With the profiled contour boards in place, add the terrain materials.

THE SCENERY KIT

Before beginning to create the terrain contours on your layout, you might like to try out the techniques and products on a practice piece. To assist you, we have created **Woodland Scenics The Scenery Kit**. See photo on Page 132. The Scenery Kit is designed as a learning tool which has specific directions to help you learn terrain and landscaping modeling. The kit contains everything you need in one box to begin using the Terrain and Landscaping Systems right now. The end result is a *diorama* or miniature scene. The 10" X 18" completed diorama can be used to display an engine or piece of rolling stock and you will receive valuable practice while building it. The kit includes complete instructions plus the pre-cut hardboard sides, Plaster Cloth, Lightweight Hydrocal, rock castings, Culvert, track, Ballast, Talus, six colors of Turf, two colors of Clump-Foliage, Field Grass, Poly Fiber, four Earth Color Liquid Pigments, Trees, Hob-e-Tac Adhesive, and Scenic Cement to build the diorama. (Descriptions and instructions for all these products can be found in the next two chapters.)

By following the instructions carefully, you will not only learn the techniques for using a large number of the terrain and landscape products, but you will also create a diorama you can be proud of as a display item. The Scenery Kit allows you to get started even though you may not have your layout benchwork in place or track laid. The Scenery Kit could also be used as a learning tool in model railroad clinics or club meetings.

Chapter II

TERRAIN

Building terrain contours for models and model railroads has evolved and improved over the years due to better products and the easier methods of working which the products permit. The purpose of this chapter is to teach you the easiest and quickest way to make terrain contours with the help of these products and methods. The basic terrain building steps are defined in this chapter.

PLANNING TERRAIN

Few land areas are flat for more than a short distance. Terrain of varying heights not only makes the railroad look more natural, but it also adds the illusion of greater space by allowing the trains to briefly disappear from view and then reappear again. Take a look at the plan created for the railroad to see where hills or mountain areas are located. These are some of the first terrain features that will be built.

If building one or two modules as the entire layout or using a flat piece of plywood, use varying terrain areas to create some *view blocks* or obstructions that allow the trains to play *peek-a-boo* with the viewer. Using terrain of varying heights can also help prevent viewers from perceiving that the trains are merely running around in a circle. It is easier to finalize the track plan and lay track before beginning terrain. This allows the exact perimeters of the terrain area to be known.

Within a modular group, the available area for terrain features will pretty much be decided by the module specifications. The scenery on a module may be required to be compatible with the other modules or at least the ones that will be located adjacent to it. If a module is planned for part of a rail yard or a city area, there might not be much selection on what type of terrain would be built. The group may want the terrain areas to flow realistically from one module to the next.

When building a module that will eventually be part of a larger home layout, decide which section to begin building now. Is it a rail yard, a section of main line track through a town, or a tunnel area through a mountain? It will be helpful to consider the terrain for the entire railroad before beginning on the first module, but it will not really matter which module is built first.

With a larger layout, let your imagination go. Many types of terrain can be included in one layout. Perhaps the entire layout will be mountainous or maybe the mountains will be confined to one area, building up to them with rolling hills and dropping off to nearly level land. Keep in mind that real railroads go from one place to another and they exist for a purpose. Therefore, be sure to plan some room for towns, industries, and rail yards.

MOUNTAINS, HILLS, AND OTHER TERRAIN

There are many terrain possibilities available for the layout. Flat land can flow into rolling hills which rise to become foothills and finally mountains. Any part or all of this chain can be modeled successfully. Remember that mountains seldom exist individually. They are usually grouped together in mountain ranges. The same is true for hills. Groups of rolling hills are much more common than one hill set in the middle of flat land. There is probably not room on the layout to put in entire mountain ranges or groups of hills. This is where selective compression comes into use in developing scenery. By building a mountain or two and using a backdrop that continues this theme, the illusion of an entire mountain range is created.

Model builders have created several ways to build terrain contours involving different materials and varying amounts of required skills. A method of mountain building developed in the 1920s is to cut the desired terrain profiles from plywood and attach them to the benchwork at intervals in the terrain area. Metal screen wire is then attached to these profile boards to form the raised shape of the mountain. The wire is covered with paper towels dipped in plaster to complete the form and give it a hard shell. This is a relatively slow technique for building terrain and may be somewhat difficult for beginners. Due to the kind of materials used, it is also fairly expensive.

Another method that gained a following is to use *papier-mache* to build the mountains and hills. Papier-mache is inexpensive but is not very desirable. It is extremely messy to work with and takes a long time to dry, particularly in wetter climates and wetter seasons of the year. In addition, the adhesive materials in papier-mache are frequently attractive to insects.

Styrofoam has gained popularity in recent years as a building material for terrain. Woodland Scenics new revolutionary SubTerrain Foam is a high density, expanded, nontoxic beadboard Styrofoam that is available in hobby stores. More about Styrofoam can be found on Page 32.

Another terrain building method in this evolutionary process is creating terrain areas with wadded up newspapers and masking tape. This method is inexpensive; the materials are readily available; it is simple and fast; and beginners can get excellent results. Depending on the particular type of terrain contours being built, you may want to combine the newspaper and

masking tape terrain with a technique of using cardboard strips to bridge gaps and create higher contours. The newspaper or cardboard contours do not need strength themselves because they will be covered with Woodland Scenics Plaster Cloth. The Plaster Cloth provides the strength and is self supporting. See Page 30 for more information on Plaster Cloth.

NEWSPAPER AND MASKING TAPE TERRAIN

Creating terrain areas from newspapers and masking tape is quick, easy, and inexpensive. It allows even a beginner to do a good job because it makes experimentation simple. There are no expensive materials to ruin or waste, and whole mountains and hills can be easily moved around, made larger or smaller, or eliminated entirely. This is also a good method for modelers who want to add some contour areas to an existing layout because it creates less mess and less destruction to the current scenery.

Collect a stack of old newspapers and begin tightly wadding each sheet into a ball. Make some larger and some smaller wads. These are the building blocks. Now go to the layout and stack up the newspaper wads on the terrain base to form the contours. Use the masking tape to hold the wads in place

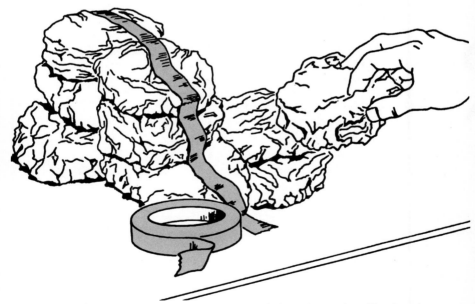

Stack wadded up newspapers on the terrain base to create rolling terrain, hills, and mountains. Cover with strips of masking tape to hold in place. The newspaper wads can be rearranged, moved around, added to, or removed in experimenting with different terrain before the final form is achieved.

by attaching long strips to cover areas. Use more wads for larger hills and stack them higher. Do not worry about the final sculpting now. Just get the general shapes and locations desired.

Stand back and look at what you have created. If it does not look quite right, readjust the wads, add and subtract wads as needed, or move whole hills to a new location. Experiment with rolling hills, large mountains, and undulating plains. They can always be removed if desired, and almost nothing will be wasted in cost of materials.

If you have trouble visualizing these mounds as terrain features, place a sheet of newspaper over the wadded up paper and use the **Woodland Scenics Scenic Sprayer** to wet it down with a fine mist of water. The newspaper sheet will conform to the shape that has been created and provide a better idea of how the contours will look. Newspaper wads can still be added or removed as needed.

Be certain that there is enough clearance surrounding the tracks for the trains to get through. Try rolling a boxcar over the tracks to see if it hits any newspaper or derails anywhere because of newspaper wads. If it does, remove a few wads of newspaper. Also notice the places where buildings are planned. Has enough open space been left for the size of building being planned for the area? Although it is easy to remove some of the terrain material later on if needed, save some time by considering these items ahead of time and making allowances for them.

TECH TIP

When making newspaper wads for terrain building, the best shape for the wads may be a pillow shape. Start with a sheet of newspaper and roll the edges underneath from each side until a small pillow with a gently curved top, slightly concave bottom, and rounded edges is achieved. These pillow shaped newspaper wads will be easier to stack up than wads of miscellaneous shapes to form the terrain contours.

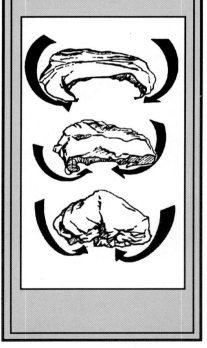

CARDBOARD STRIPS

In some instances it may be better to use strips of cardboard rather than newspaper wads to create the terrain contours. This is another inexpensive

method of terrain building which produces quick results and can readily be changed if the first effort is not desirable. Although newspaper wads are quick and easy to use for rolling terrain and smaller mountains, it may be faster to use cardboard strips to create very large mountains and to bridge gaps between levels of track. These two terrain building methods can easily be combined on one layout and both can be completed with Plaster Cloth. See Page 31.

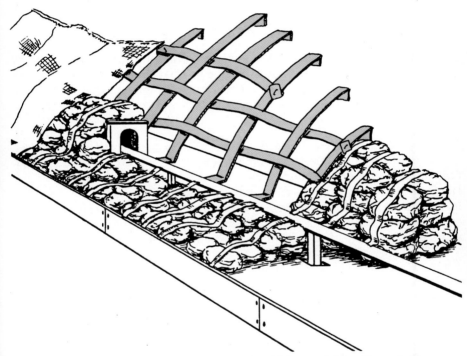

Cardboard strip contours work well to create high mountain profiles or bridge the gap between two levels of track. Add the vertical strips first by stapling or gluing them to the benchwork, terrain base, or sub-roadbed on the bottom level, and the back profile board or sub-roadbed of the upper track on the top level. Continue by adding the horizontal strips then cover with Plaster Cloth for a hard terrain shell. See Contour Finishing on Page 31.

To make cardboard strip terrain contours, use the corrugated cardboard from boxes and cut the strips approximately one inch wide with scissors, a hobby knife, or paper cutter. Strips of various lengths will be used and short strips can be made into longer ones by stapling the ends together.

Attach the vertical strips to the layout first, then the horizontal ones. To build the form for a large mountain, attach one end of the cardboard strips to the benchwork or terrain base where you want the base of the mountain at intervals of every few inches. Staples, Woodland Scenics Flex Paste, Woodland Scenics Hob-e-Tac, or white glue may be used for attaching the strips, depending on the underlying material. Then bend the strips into the shape of the mountain you want and attach the top ends of the cardboard strips to the wall or contour board behind. If the cardboard strips are too long, simply cut off the excess or fold under. If the strips are too short, staple or glue on an additional strip. When this is completed, add the horizontal strips on top of the vertical ones at intervals of every few inches, stapling or gluing each joint with the vertical strips. Spring-type clothespins or paper clips can be used to hold glued joints together until dry. The horizontal strips may be woven into the vertical ones if desired.

If the mountain is not quite what you had in mind, change the shape by pushing in on the cardboard strips to cave in some areas. Or cut the strips and reglue or staple to make a different form. If the mountain form is not at all what you wanted, remove it and begin again. Very little time or material has been wasted.

The cardboard strip method also works well to bridge the gap between different levels of track. Attach the vertical strips of cardboard to the sub-roadbed material of the bottom level of track with staples or glue. Then staple or glue the upper ends of the cardboard to the sub-roadbed of the upper level of track. Add the horizontal cardboard strips. When this contour is covered, it will provide a surface where rock outcroppings or whole rock walls can be added. See section on Contour Finishing. Page 31.

After putting the cardboard strips in place, check to make sure there is sufficient clearance between them and the track so trains will not derail. If problems exist in this area, you may need to unstaple and reposition the bottoms of the vertical strips.

At this point, decide if you want to include any tunnels, tunnel portals, retaining walls, culverts, roads, or water areas on the layout. Although these features can be added at any time, it is generally easier to fit them in while building the original contours. If you want to add any of these features, take a few minutes now to read the sections of this book about them.

PLASTER AND TERRAIN SHELL

Plasters have generally been the material of choice to complete the terrain contours on the layout. They are used for creating the hard *terrain shell* on top of the terrain contours, for casting rocks and other items, for filling in holes and breaks in scenery, and for detailing terrain areas. Because plasters

are so important, we are going to consider the different kinds, their uses, and properties before continuing to complete the terrain shell.

Woodland Scenics Lightweight Hydrocal* is specially formulated for terrain modeling. It is used to cast rocks and as an extra durable coating on top of Plaster Cloth. See Page 32. It is also used to fill in open spaces around plaster castings and as an adhesive for joining plasters and castings. Lightweight Hydrocal is easily mixed with water to form a tough plaster shell or to pour into molds. See Rock Molds section for complete instructions on casting. For maximum strength, mix Lightweight Hydrocal according to the package directions. Even when dry, it can easily be carved with a hobby knife or dental pick to add details or allow rock castings to fit together. Always wet the adjoining plaster surfaces when using Lightweight Hydrocal as an adhesive. Modelers who build modules or other models that will be moved will particularly appreciate this lighter weight product.

Woodland Scenics Mold-A-Scene Plaster is a sculptable plaster that can be shaped without a mold, similar to modeling clay. It is also formulated specially for terrain modeling and can be used to add detail, repair holes and breaks in the scenery, or change the original contouring. It can be used to build up the banks of a river, blend a raised railroad track into the terrain, or enhance a mountain area that did not turn out quite right. Mold-A-Scene provides the opportunity to work with the plaster, shaping or sculpting it to fit an area. Mix it with water according to package directions for maximum

*Hydrocal is a product of U.S. Gypsum

TECH TIP

Plaster is a porous material which accepts color by absorbing it into the pores. If anything occurs to close the pores on the face of a plaster casting, it will not accept a color wash. Do not sand or mar the face of a plaster casting that is to be colored. A marred area will appear much lighter when stain is applied. If this occurs, daub on more concentrated Earth Color Liquid Pigments. It may help to use a hobby knife to rough up or chip away the lighter areas and then restain.

When installing rock castings using the brick method, some Lightweight Hydrocal will ooze out around the rock. It can be removed by water carving, that is, spraying with a solid stream of water from the Scenic Sprayer until the Lightweight Hydrocal washes away. See illustration in Tech Tip on Page 43. Or, leave the excess in place until it dries, and use a hobby knife to chip it off. Do not use sandpaper.

Glues on the face of castings will prevent the casting from accepting stain in that area. You may want to stain sections of plaster castings before assembling them. If glue does get on a face, use a hobby knife to chip the glue away. Or, daub on undiluted Liquid Pigments. See Coloring Plaster Castings section for additional information.

strength and pack it tightly together for best results. Mold-A-Scene will set up in approximately 20 minutes to a hard, durable plaster surface that can be colored, carved, or detailed.

Woodland Scenics Plaster Cloth is a plaster coated cloth designed for terrain modeling. Use it to cover the terrain areas to form a hard terrain shell that easily accepts coloring, rock castings, and landscape material. It is also used to fill in terrain cuts and resculpt around terrain features. Because it comes in a roll, it is easy to cut off just the amount needed to cover the work area. Dip the cloth in water and place it where desired. There is little mess and no left over plaster to harden before it can be used. Plaster Cloth dries completely in about 30 minutes to provide a tough, durable terrain shell.

Hydrocal* and Molding Plaster have been used by model railroaders for many years for casting rocks and completing the terrain contours. They are very heavy products, making them particularly difficult to use with a module or other layout that will be moved around. When dry, Hydrocal is extremely hard and very difficult to carve. Molding Plaster is somewhat easier to carve, but is still not desirable. If you plan to use either of these products to cast rocks, the Woodland Scenics Rock Molds can be used with them. The older method of creating terrain contours included plywood profiles, screen wire and paper towels dipped into a plaster and water mix. If you choose to dip paper towels in a plaster and water mix, a lightweight durable terrain shell can be created by using a Lightweight Hydrocal and water mixture to coat the paper towels. This is a messier

*Hydrocal is a product of U.S. Gypsum.

TECH TIP

Lightweight Hydrocal can be used to create terraces, berms, and raised roads. Sculpt these items by cutting a pattern from styrene.

Mix a small amount of Lightweight Hydrocal to a thicker consistency than is recommended on the package by adding extra Lightweight Hydrocal. The thicker consistency will cause fast setting, so be prepared to work quickly. Spray water from the Scenic Sprayer on the surface before applying the Lightweight Hydrocal. Place the Lightweight Hydrocal on the terrain base in the area where the feature is to be located. Use the styrene pattern like a trowel to shape the land feature. More water sprayed on the Lightweight Hydrocal will help to keep it workable while the land form is being shaped.

Tire tracks in roads or other detailing can be marked in the wet Lightweight Hydrocal.

procedure than using Plaster Cloth and results in more waste because the plaster usually hardens before it can all be used.

CONTOUR FINISHING

Once the basic terrain areas are completed with newspaper wads and masking tape or cardboard strips, the contours are ready to be finished. A hard surface must be created on top of the newspaper wads or cardboard strips which is strong and self supporting, and will make it possible to add coloring and landscape materials. This is known as the terrain shell. A terrain shell covering is formed on all contour areas built from newspaper wads or cardboard strips. It

Cut strips of Plaster Cloth to manageable sizes. Dip each strip in water and place over the terrain material with the bumpy side of the Plaster Cloth up. Plaster Cloth can be used over newspaper wads, cardboard strips, screen wire, or SubTerrain Foam. Shingle each strip 50% on the previous layer and 50% on new territory. Rub your hand over the wet Plaster Cloth to fill holes and smooth out the sheet. Fold over the Plaster Cloth onto itself at the edge of the layout or module where the material meets the benchwork, terrain base, or plywood. This makes a neat clean edge.

is not necessary to use it in flat open areas or under track. If using paper towels dipped in Lightweight Hydrocal to create the terrain shell, be sure to cover the track with strips of newspaper taped in place before continuing. This will keep the track clean and free from dripping plaster. With Plaster Cloth there is much less mess and track covering should not be needed.

Plaster Cloth makes creating the terrain shell a simple process by permitting the newspaper wad or cardboard strip areas to be easily and conveniently covered. The Plaster Cloth roll allows cutting off only the amount needed to cover an area with no waste. The cloth structure holds the plaster in place and allows the pieces to be placed just where needed with no mess.

To use Plaster Cloth, simply cut strips of manageable sizes off the roll with scissors. Note that the Plaster Cloth has a smooth side and a bumpy side. The cloth structure can be seen more easily on the smooth side while more plaster is evident on the bumpy side. For the best use of the Plaster Cloth, use it with the bumpy side up. Dip the Plaster Cloth in water and lay it on the newspaper wads or cardboard strips. The Plaster Cloth will adhere to the shapes that have been created. Use the *shingle method* to overlap sheets of Plaster Cloth 50% on the previous sheet and 50% on new territory. While still wet, rub the Plaster Cloth to fill in the holes and smooth out the sheet. Using the sheet of Plaster Cloth with the bumpy side up makes more plaster available for this smoothing and hole filling process.

Plaster Cloth can be cut to whatever shapes and sizes are desired for a particular situation. After wetting, Plaster Cloth remains pliable for three to four minutes, so some reshaping of newspaper wads can be done. Plaster Cloth will dry completely in about 30 minutes to form a tough, lightweight base for other terrain items and for landscape material. There may be some wrinkles that develop as the Plaster Cloth dries, but these will not adversely affect the terrain and will give some additional needed texture when applying landscape materials later on.

In areas where you will be adding a lot of weight, you may want to add another layer of Plaster Cloth for added strength. Or, apply a layer of Lightweight Hydrocal on top of the Plaster Cloth with an inexpensive synthetic fiber brush or trowel.

If the Plaster Cloth is rewetted during any of the terrain or landscape building, it will soften slightly. You may want to do some additional shaping of the Plaster Cloth after rewetting to create a space for a culvert or rock castings. The Plaster Cloth will redry holding the new shape.

STYROFOAM®
Another accepted method used by some modelers to create rolling terrain is to use Styrofoam. Woodland Scenics SubTerrain Foam is a high-density

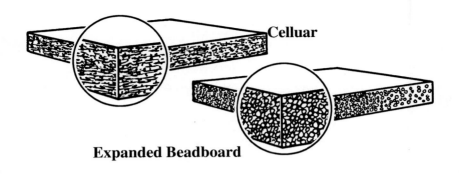

Celluar

Expanded Beadboard

Woodland SubTerrain Foam is a high density expanded beadboard Styrofoam. We recommend using the SubTerrain Foam for terrain modeling because no toxic fumes are emitted when cut, there is no film to remove, it comes in a variety of sizes and is available at better hobby stores everywhere.

expanded beadboard Styrofoam that emits no toxic fumes when cut with a hot wire cutter, Cellular Styrofoam is made with chemicals that produce toxic fumes when cut.

Woodland Scenics SubTerrain Foam is ready to use. Begin with the bottom layer of a particular hill and cut out its base with a utility knife or *hot wire*. Move on to the next and smaller layer, stacking them up to see how they will look. Later on, the layers will be glued together, filed and finished. If you are using Cellular Styrofoam, prepare by stripping off any plastic, paper, aluminum foil, or fiber covering the outside of the Styrofoam. Also, remember toxic fumes may be emitted from this type foam when cut.

When the layers have the desired shape and are in the appropriate location, glue each layer to the one below it. Keep in mind that white glue does not work well with Styrofoam. Because Styrofoam is a non-porous material, air does not circulate through it and the glue will not dry thoroughly. The best adhesive materials for any kind of Styrofoam are Woodland Scenics Foam Tack and the Woodland Scenics Low Temp Glue. These procducts are designed for the SubTerrain System, but can also be used with Cellular Styrofoam. Once the glue is applied, it may be helpful to push Woodland Scenics Foam Nails through several layers of the Stryofoam to hold them in place while the adhesive dries.

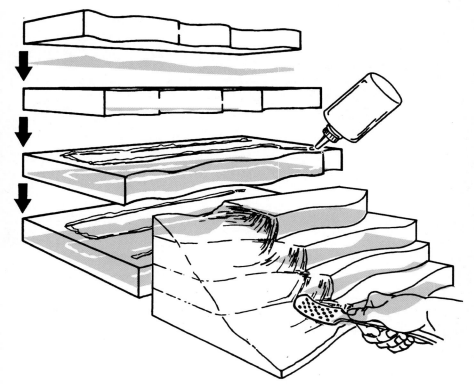

To use Styrofoam for terrain, first cut the bottom layer of a hill or mountain. Then cut successive layers and stack them up. When you like the shape, glue each layer to the one below it. The stacks should resemble terrain contours. To complete the contours, file off the square edges and round the mound into a hill.

Be careful with any type of solvents around Styrofoam because they can dissolve it. When weathering, sanding, or attaching detailed parts to Styrofoam, be sure to test the solvent you intend to use on a scrap piece of the Styrofoam.

Finishing Styrofoam contours can be done in two ways. If you want to use a modeling paste type of finish, paint on a layer of **Woodland Scenics Flex Paste** with a stiff bristle acrylic brush to seal and smooth the Styrofoam. Flex Paste is a modeling paste which is specially formulated so it will not crack or shrink as it dries. This flexibility is particularly important when covering contours because you are trying to cover cracks and breaks in the terrain, not create additional cracks and breaks. Flex Paste may be thinned with water if a particularly thin coating is desired.

The contours may also be finished with a coating of Lightweight Hydrocal. If you're not using Woodland Scenics special high-density SubTerrain Foam, Lightweight Hydrocal will not readily adhere to the Cellular Styrofoam. You may have to use a rasp to roughen the surface of the Cellular Styrofoam. If the foam is damaged during sanding, or at any other time, use Woodland Scenics Foam Putty to repair it. Foam Putty shares characteristics with Styrofoam that make it easy to sand and finish without detection. With either method of contour finishing, plaster castings can be installed later on using Lightweight Hydrocal as an adhesive and mortar between the castings.

In areas where rock castings are not planned for installation, Woodland Scenics Earth Color Liquid Pigments can be mixed directly into Flex Paste to color it before applying. However, we prefer to apply Flex Paste to the Styrofoam and color it after it dries with Earth Color Liquid Pigment.

TUNNELS

As the terrain on the layout is built, be sure to consider some of the optional features that can add both realism and interest to the railroad. These options include tunnels, retaining walls, culverts, and rock outcroppings. They are easy to install during the beginning stages of a layout but can also be added later to a more complete layout.

Railroad companies built many tunnels through mountains and hills. They used them as a way to avoid the extra cost and danger of building track over mountains, and to shorten the amount of distance between points. If your railroad includes mountains or hills, consider adding a tunnel for realism and to give the trains a chance to briefly disappear from view. There may be a section where a tunnel would be appropriate even if extremely high mountains are not being modeled. But no railroad company would have built a tunnel where there was so little rock above it that a simple rock cut would have been faster and less expensive to build.

Tunnels are most easily planned into the scenery at the time terrain contours are being created. It is usually easier to build the tunnel first and then add the terrain contouring material over it. The track going through the tunnel will need periodic cleaning and there is always the possibility of a derailment inside the tunnel. For these reasons, tunnels need to be constructed so there is access to the inside.

Because the tunnel will be enclosed inside a mountain, it will be necessary to have an opening in the mountain or benchwork to get to the tunnel. The mountain can be left open on the back, if the opening is away from the sight of viewers. This opening allows an access area which can be reached from the back of the layout or underneath through the benchwork, allowing work

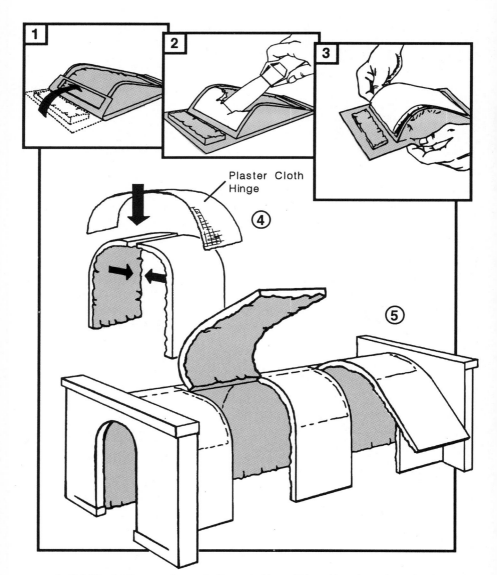

Plaster Cloth Hinge

1. Fold the bottom section onto the main Tunnel Liner Form to make a single track width. Use the whole form for a double track tunnel liner. 2. Fill the outside curve (convex side) of the form with Lightweight Hydrocal, leveling off even with the side ridges. Allow to dry. 3. Pull out on the sides of the form to allow the casting to pop free. 4. Complete one unit of tunnel liner by joining two half sections on top with a strip of Plaster Cloth. Spray the sections first with water. The Plaster Cloth forms the hinge allowing the tunnel to be opened. 5. Connect units of tunnel liners with Lightweight Hydrocal reinforced by Plaster Cloth on the side which will not be raised. The units on the side to be raised can all be connected so the whole side is raised as one piece, or the sections can be left separate to be raised individually.

on the track as needed. If this is not possible, consider either a *lift-off panel* for the mountain to provide access, or an entire mountain that lifts off the layout area over the tunnel. Where the tunnel is located on the layout may help determine which of these solutions will work the best.

TUNNEL LINERS

There are two important considerations for tunnels. First, a tunnel must have the proper shape and size to allow the trains to pass through without coming into contact with the tunnel walls. And second, a tunnel needs to realistically resemble the rock from which it has been cut. Woodland Scenics has taken both features into consideration when designing the **Woodland Scenics Tunnel Liner Form**. Each casting from the form with Lightweight Hydrocal will produce one half of a tunnel section in either *single* or *double track width*. These halves are then connected on the top with a strip of Plaster Cloth which forms a hinge. The entire half of the tunnel liner that will remain stationary is attached directly to the terrain base while the other half can be raised for repairs to the track.

To make a section of liner, mix Lightweight Hydrocal and water according to package instructions. For a double track width, use the entire mold. For single track, fold the bottom section onto the main form area to shorten the top width of the tunnel liner. See the illustration on Page 36. Continue stirring the Lightweight Hydrocal until it begins to congeal. Then with a spatula, quickly fill the outside curve (convex side) of the mold with the Lightweight Hydrocal and level it off even with the side ridges. Allow the Lightweight Hydrocal to dry for approximately 30 minutes before removing the tunnel liner from the form. An easy method of removing the casting from the form is to pull out on the two sides of the form allowing the casting to pop free. Handle the casting as little as possible while still damp. Continue drying the casting overnight before coloring. Make as many sections as are needed for the tunnel length on the layout.

Assemble the tunnel liner by smoothing the edges of all sections and trial fitting. This is the time to add any additional detailing with a hobby knife or to smooth out any holes left by air bubbles in the Lightweight Hydrocal. The inside of the tunnel liner sections should be colored to look like the rock of the terrain area being built. At least part of this tunnel liner will be visible to viewers and will not look natural unless it looks like rock. Coloring the inside of the tunnel liner can be done with Woodland Scenics Earth Color Liquid Pigments. Follow the directions under the Coloring Plaster Castings section of this book.

The tunnel liner sections are put together with a strip of Plaster Cloth. Cut the Plaster Cloth as wide as the individual tunnel section and long enough to cover the entire top of the two tunnel liner half sections. Spray the top of the tunnel liner sections with water. Then dip the Plaster Cloth in water and

place over the top of the tunnel sections forming a hinge. Even when dry, the Plaster Cloth has enough flexibility to allow one half of the tunnel liner to be raised for servicing the underlying track. If the tunnel is long enough to require more than one of these units, the units can be joined with Lightweight Hydrocal, reinforced by strips of Plaster Cloth on the stationary side. Be sure to spray or paint water on adjoining sections before applying the Lightweight Hydrocal. If the pieces are not wetted first, the Lightweight Hydrocal will not be effective as an adhesive.

As the terrain is shaped with newspaper wads or cardboard strips, create the locations for tunnels and install the tunnel liners. Use Lightweight Hydrocal to attach the entire stationary side of the tunnel liner to the layout, being careful to position the tunnel liner so one side can be lifted. Be sure to wet both plaster surfaces with water before using Lightweight Hydrocal as an adhesive. If appropriate, Flex Paste or white glue can also be used for attaching the tunnel liner.

TECH TIP

Although the Tunnel Liner Form is designed to be used in HO scale, it can be modified for other scales. For N scale, both the width and height need to be decreased. One method is to cast the entire mold and cut off the excess with a hacksaw. Or, cut dams from styrene and glue onto the original form to decrease the length and width before pouring the mold. To use with scales larger than HO, make multiple pours of the form in HO scale. Enlarge the tunnel liner by cutting up some of the liners and using these pieces to add on to the height and width of an HO liner. These pieces can be added to the original liner with Lightweight Hydrocal reinforced by Plaster Cloth on the back side.

TUNNEL PORTALS

In most instances, railroads finished off their tunnels with tunnel portals. Tunnel portals are the stone, concrete, or timber facings built at the entrances to tunnels to hold back rock and dirt from around the tunnel entrance. Sometimes these tunnel portals carried the name of the tunnel, the name of the railroad building it, or the date it was built. Once the tunnel liner is in place, finish it with a tunnel portal if desired. **Woodland Scenics Tunnel Portals** are made from high-density plaster which can easily be stained and further detailed. They come in both single and double track widths, in various styles, and are designed to fit the castings made from the Tunnel Liner Form. Select the type that best fits the locale and time period being modeled. All of the Woodland Scenics Tunnel Portals meet NMRA standards for height and width in HO scale and are adjusted to handle the tightest HO turning radius.

In many cases retaining walls are used with tunnel portals to stop rock and dirt from falling on the track. If retaining walls are going to be used with the tunnel portal, select and prepare them at the same time. Woodland Scenics Retaining Walls coordinate with the Woodland Scenics Tunnel Portals, and can be used individually or in groups.

To use a Tunnel Portal, remove any rough edges as suggested by the package directions. Trial fit the pieces with the tunnel liner as you work. Should any Woodland Scenics Tunnel Portal or other plaster pieces break while they are being prepared, repair them with super glue. This product gives the best joint between surfaces which are smooth and even. Be careful to keep super glue off the face of the Tunnel Portal. Stain the pieces according to the instructions for Coloring Plaster Castings.

If used without Retaining Walls, the Tunnel Portal can now be attached to the layout with Lightweight Hydrocal, Flex Paste or white glue. Remember to wet both plaster surfaces with water before using Lightweight Hydrocal as an adhesive. If Retaining Walls are being used, it may be easier to attach them to the Tunnel Portal before installing on the layout. Check for fit. The adjoining corners may need to be mitered to achieve a proper fit. This is easy to do by placing a sheet of sandpaper on a table and rubbing the casting over it until the proper angle is achieved. Assemble the pieces with Lightweight Hydrocal, Flex Paste, or white glue. If using Lightweight Hydrocal, be sure to wet the adjoining surfaces with water before applying the Lightweight Hydrocal. Be careful to keep Flex Paste or white glue off the finished surfaces of the pieces. See Tech Tip on Page 29.

Blend the tunnel liner and Tunnel Portal into the terrain surface using newspaper wads or cardboard strips and Plaster Cloth. Lightweight Hydrocal or Mold-A-Scene can also be used to fill in around the Tunnel Portal if needed. A lift-off mountain or lift-out section may be required in some instances to allow access to the tunnel. After the Tunnel Portal is installed, hide any seams, rough edges or repairs with vines made from Woodland Scenics Foliage material. See Chapter 3, Medium Ground Cover, Page 85.

If a tunnel is being added to an existing layout, cut a space into the existing terrain. Then hollow out the inside of the mountain to allow the track to be laid and the tunnel liner, Tunnel Portal, and Retaining Walls to fit. Any terrain recontouring that is needed can be done with Plaster Cloth strips or Mold-A-Scene Plaster by filling in cut areas to make the mountain fit snugly against the Tunnel Portal and Retaining Walls.

RETAINING WALLS

Retaining walls are built where terrain cuts and fills are required. They prevent rock and dirt from falling on tracks and roads, and they are also used

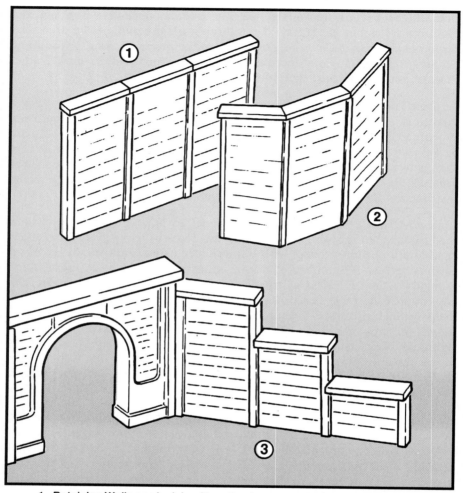

1. *Retaining Walls can be joined together in groups as pictured here or used individually. 2. By mitering the adjoining corners, walls can be made to fit around a curve. 3. Trim off various lengths from the bottom of the pieces to form stepped wing walls at the sides of tunnel portals.*

in general landscaping and terrain resculpting. Retaining walls are seen individually, butted together to form longer walls, and as extensions of tunnel portals. Sometimes a length of retaining wall is all the same height, and sometimes it is stepped to conform to the shape of the terrain. Retaining walls are often built to fit as required by the terrain.

Woodland Scenics Retaining Walls are high density plaster castings which can be cut, sanded, and stained to fit individual needs. They are cast in sections, making it possible to use them in a number of different ways. The Retaining Walls can be used alone or coordinated with the Tunnel Portals.

The wall sections can be used in the same height, stepped down, or mitered to form a curved wall. Assembling the Woodland Scenics Retaining Walls begins with removing any rough edges from all pieces. The pieces must be cut to make stepped walls or extensions of a tunnel portal. A hacksaw is the recommended tool to use. We prefer using a blade with 18 to 24 teeth per inch. To finish the pieces, lay sandpaper on a table and rub the cut edge of the piece over it until smooth. To shorten a Retaining Wall section, cut the unwanted length off the bottom of the piece.

If any section breaks while it is being prepared, repair it with super glue to achieve the best joint between pieces which are smooth and even. Stain the Retaining Walls according to the instructions in Coloring Plaster Castings. Glue the Retaining Wall sections together with Lightweight Hydrocal. Flex Paste or white glue may also be used. These adhesives provide the best joint when filling gaps between uneven surfaces. Be sure to spray or paint water on the adjoining edges before applying the Lightweight Hydrocal. Be careful to keep Flex Paste or white glue off the finished surfaces. See Tech Tip on Page 29.

If you would like to fill the joints, use a thin mixture of Lightweight Hydrocal and water. Apply with a fine water color type brush and allow *capillary action* to fill any spaces. While the joint is still wet, use a brush dipped in water to brush off any excess Lightweight Hydrocal. This is much easier to do while wet rather than waiting until the piece is dry. The Lightweight Hydrocal used for filling joints will then need to be stained in the same manner as the Retaining Walls.

Retaining Walls can be installed on the layout at the time terrain is being built. They can be used at the sides of tunnel portals or at other areas where the track would have forced cuts in the terrain. Install Retaining Walls by attaching them directly to the terrain base or terrain shell with Lightweight Hydrocal, Flex Paste or white glue. Adding Retaining Walls to an existing layout will require cutting a space in the terrain material and attaching them. Fill any gaps or repair the contouring with Plaster Cloth or Mold-A-Scene Plaster. After the Retaining Walls are installed, hide any seams, rough edges or repairs with vines made from Foliage material.

CULVERTS

Culverts are drains which help direct water by diverting it under roads and railroad tracks rather than onto them. Culverts are seen in virtually every kind of terrain, including areas where it is usually dry. Normally culvert facings appear in pairs, one on either side of the road or track, and they can be constructed from a variety of different materials. On the layout there are a number of places where culverts can fit in, no matter what type of area or scenery is being modeled. In some instances only one culvert facing will be needed since its partner will be hidden by other scenery items.

Culverts can be installed on the layout at the time terrain is built or they can be added later on. **Woodland Scenics Culverts** are high density plaster castings that can be stained and further detailed if desired. They are available in a number of different styles which are easy to assemble and install.

To assemble a Culvert, first remove any rough edges, trial fitting the pieces together as they are prepared. Should any section break, it can be easily

repaired with super glue which will give the best joint with smooth even surfaces. Stain the Culvert with Earth Color Liquid Pigments according to the directions under Coloring Plaster Castings.

Glue the sections together with Lightweight Hydrocal to provide gap filling for a joint between relatively uneven surfaces. Flex Paste or white glue can also be used to glue sections together but be careful to keep them off the finished surfaces. See Tech Tip on Page 29. Be sure to spray or paint water on the adjoining edges before applying the Lightweight Hydrocal. If desired, fill joints with a thin mixture of Lightweight Hydrocal and water. Apply it with a fine water color type brush and allow capillary action to fill the spaces. If any excess Lightweight Hydrocal gets on the Culvert pieces, dip the brush in water and brush off before the Lightweight Hydrocal sets. The Lightweight Hydrocal used to fill the joint will need to be stained in the same manner as the Culvert sections.

If Culvert spaces have not been left in the terrain, add the Culverts by using a hobby knife to slice out a small section of terrain material. Then attach the Culvert to the layout with Lightweight Hydrocal being sure to wet both plaster surfaces with water. Flex Paste or white glue can also be used. Any repairs to the terrain around the Culvert can be made with strips of Plaster Cloth or Mold-A-Scene Plaster to make the Culvert facing fit.

ROCK OUTCROPPINGS

To make the layout scene look more realistic, the next step is to add the natural terrain features known as rock outcroppings. These come in all sizes from simple field rocks to entire rock cliffs. If you have photos of an actual location being modeled, study them to see what is in the area. Different areas of the country have widely different types of outcroppings. In modeling a mountainous area, there would be some rock cliffs and rock walls as well as large boulders and surface rocks. In areas of rolling hills there might be rock cliffs leading down to a river bank, miscellaneous surface rock, boulders and

perhaps embankments. In flatter areas of the country, field rock, small boulders, and eroded creek and river beds would be seen.

In addition to the differences in the types of outcroppings, different areas of the country feature various geologic types of rocks. Rock from volcanoes or rock that comes to the surface in a molten form is usually more massive. Rock that has been created in areas that were once under great seas is made from deposited layers of dirt, sand, and animal remains. This rock is layered, sometimes with each layer being a slightly different color.

In general, rock outcroppings are added to the layout by casting rocks from Lightweight Hydrocal and attaching them to the terrain shell that has been created. In this manner, one or two outcroppings or a whole wall of rock can be added to the layout. Woodland Scenics Lightweight Hydrocal is preferred for casting rocks because it is easy to sand, carve, and detail, as well as being light enough for modules or other layouts that will be moved. Rock outcroppings can easily be installed on the layout at the time other terrain features are created or they can be added as a detailing feature to a more complete layout. The rocks can be colored either before attaching them to the terrain shell or after they are in place.

To obtain rock molds, either purchase them preformed or make your own molds. Highly detailed **Woodland Scenics Rock Molds** are available in a wide variety of different sizes and configurations to meet most modeling needs. Also available is **Woodland Scenics Latex Rubber** for making molds

TECH TIP

In some areas you may want rock castings to fit tightly together. When making castings from Lightweight Hydrocal, there is an easy way to accomplish this. First cast several rocks. Place the edge of one over the edge of another and trace the outline of the top rock onto the bottom one. Then use a hobby knife to carve away this marked section on the bottom rock. Install the rocks with Lightweight Hydrocal as an adhesive. Because of the tight fit you have carved, there should be little space between the two rocks. Use water from a Scenic Sprayer, adjusted to a stream rather than spray, to remove any excess Lightweight Hydrocal that oozes out between the rocks.

of your own. Almost infinite variety can be achieved in the rocks installed on the layout if several of the Rock Molds are used and if the rock castings are turned and positioned in different ways. Be sure to keep scale in mind when making your own rock molds. Rocks in the real world come in many sizes. But be sure to note the layering and texture of the rocks when planning to make molds of them as those found in the real world may look grossly out of scale on a model.

Smaller rock debris which is continually breaking away from rock cliffs, rock outcroppings, and mountains is known as *talus*. This rock is too small to cast but is prepackaged by Woodland Scenics. Talus comes in several colors which will blend with many rock colors, or the Talus can be custom colored in the same manner as rock castings. For more information on the application of Talus, see Page 79.

ROCK MOLDS

Before beginning to cast any rocks, decide how they are going to be attached to the terrain shell that has been created. We recommend the *brick method* of attaching rocks. This method involves casting a number of rocks then installing them on the layout like bricks, fitting and shaping as they are

To create a rock casting, spray the inside of the rock mold lightly with wet water (one or two drops of liquid soap in 6 oz. water). Pour in the Lightweight Hydrocal, trying to avoid as many bubbles as possible. Tap the mold gently to help dislodge air bubbles. You may want to support the mold to prevent distortion. To create variety in castings, purposefully distort the mold when pouring in the Lightweight Hydrocal. Allow the casting to dry before removing from the mold. This usually requires a minimum of 30 minutes.

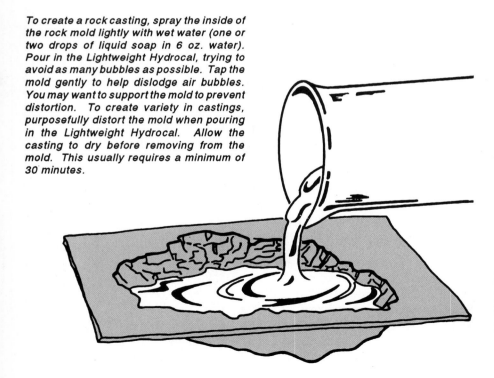

placed. Another method of installing rocks is the shingle method. With this method the rocks are attached to the terrain shell while they are in the molds and the Lightweight Hydrocal is still wet. Either method will work to attach rocks to a terrain shell made of Plaster Cloth or Lightweight Hydrocal. If you have a terrain area covered with Flex Paste where you want to attach a rock, rough up the Flex Paste with coarse sandpaper and attach the rock with Lightweight Hydrocal using either the brick or shingle method. Or use more Flex Paste as an adhesive being careful to keep it off the surface of the rock. See Tech Tip on Page 29.

Casting Rocks: Lightweight Hydrocal is ideally suited to casting rocks because it reduces the weight, and makes sanding, carving, and shaping the rocks to fit not only possible, but easy. Be sure to use clean bowls and utensils when mixing Lightweight Hydrocal. Dried Lightweight Hydrocal flakes which contaminate a mixture will weaken the castings and alter the drying time.

TECH TIP

When mixing Lightweight Hydrocal, have some extra Rock Molds available. Use up any Lightweight Hydrocal left over from another molding project by casting a rock or two. Parts of the larger Rock Molds can be used to create new shapes of rocks. Save these castings to use later as field rock, boulders, or rock outcroppings on the layout. They can also be used as practice pieces for the Earth Color Liquid Pigment coloring system.

To pour a Rock Mold, mix Lightweight Hydrocal according to the package directions, measuring the amounts of Lightweight Hydrocal and water. Lightly mist the inside of the mold with *wet water* (one or two drops of liquid soap in 6-oz. water) to help disperse air bubbles in the Lightweight Hydrocal. Pour the Lightweight Hydrocal into the mold, trying to avoid as many air bubbles as possible. Tap the mold lightly to help dislodge air bubbles. Thoroughly dry before removing from the Rock Mold, usually a minimum of 30 minutes.

More variety in castings can be obtained by intentionally distorting the molds before pouring Lightweight Hydrocal into them. Place the molds in a box of sand or wadded up newspapers to hold them in place while the Lightweight Hydrocal is being poured and drying.

In some cases you may find that rock castings removed from the molds are flaking, that is, part of the plaster from the face of the casting remains in the mold. This flaked surface may or may not look realistically like rock and it will not accept stain in the same manner as the rest of the casting. One reason for flaking is removing the casting from the mold before it is

completely dry. Try lengthening the setting time, perhaps as long as overnight. If there is still a problem, it is probably because the Lightweight Hydrocal and water were not mixed in the proper proportions. Check the package directions and be sure to weigh or measure the Lightweight Hydrocal and water carefully.

<u>Brick Method of Rock Application:</u> To use rock castings in the brick method, first cast a number of rocks and let them dry. The Lightweight Hydrocal is easily carved with a hobby knife or dental pick. Do any shaping that is needed to fit the rocks together in the area where you are working. In fact, the rocks will carve themselves if the joining edges of two rocks are rubbed together until they sand each other into a fit. If large sections of the rock casting are to be removed, cut with a knife for a rough fit first. Any additional detailing should be added to the rocks at this time.

To attach the rocks, first mix a small amount of Lightweight Hydrocal. Next, spray both the terrain shell and the back of the rock with water. Then, apply the Lightweight Hydrocal to the back of the rock with a spatula and place the rock on the terrain shell, holding it briefly in place until setting begins. It takes three to four minutes before the Lightweight Hydrocal begins to set up,

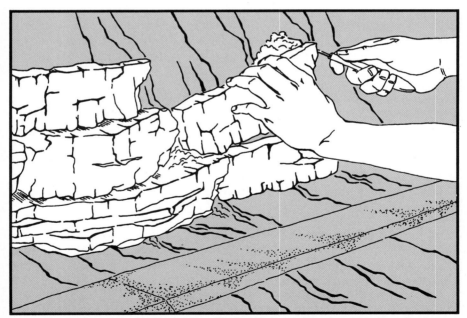

To attach rocks using the brick method, make a number of rock castings from Lightweight Hydrocal and let them dry. Carve or shape the rocks as needed with a hobby knife or dental pick to make them fit the area. Spray the rock and the terrain shell with water. Then attach by applying a Lightweight Hydrocal mixture to the back of the rock as an adhesive.

so there is some time to move the rock into the proper position. Some excess Lightweight Hydrocal may ooze out around the rock. Leave this excess in place to help provide some adhesive for the adjoining rocks and to serve as a gap filler between rocks. After the Lightweight Hydrocal has dried, any excess can be easily chipped away. See Tech Tip on Page 29. Complete setting of the Lightweight Hydrocal will take place in about 30 minutes.

Shingle Method of Installing Rock Castings: An alternate method of installing rock castings is the shingle method. This involves using the Lightweight Hydrocal in the Rock Mold as its own adhesive for attaching to the terrain shell. Installing a rock by shingling takes place before the Lightweight Hydrocal in the Rock Mold is dry. Therefore, the mold must stay attached for the entire drying time. Each new rock that is added is shingled over the edge of its neighbor. A second rock cannot be added in the same area until the first is dry and the mold for it is removed. This makes shingling a slow process of working.

Plan to pour only one or two Rock Molds at a time in shingling. When Lightweight Hydrocal is first poured in a mold, it looks shiny and wet. When

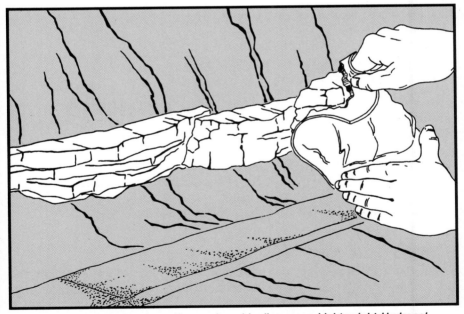

When attaching rock castings using shingling, pour Lightweight Hydrocal into the mold while it is on a flat surface and wait for the Lightweight Hydrocal to partially set. Then place the rock, with the mold still attached, into the desired location and press firmly against the terrain shell. Leave the Rock Mold attached until the Lightweight Hydrocal is firmly set, and carefully pull off the Rock Mold. Successive rocks are attached with the edge of each one shingled slightly over the edge of the previous rock.

dry, it appears dull. Look for the transition point when the Lightweight Hydrocal is just beginning to set. At this point the shine will begin to skim over. To install the rock, first spray the terrain shell with water, then press the wet rock and its mold firmly against the terrain shell in the desired location. Hold in place until it sets sufficiently to attach. Leave the Rock Mold in place for the entire drying time of at least 30 minutes and then pull it off carefully. If you experience flaking when pulling off the Rock Mold, allow a longer drying time. After drying, chip off any excess Lightweight Hydrocal from around the rock and blend the rock into the other castings by removing any edges that seem to stand out too far. See Tech Tip on Page 29. The next rock mold can then be poured and attached with its edge slightly shingled over the neighboring rock. Use a hobby knife or dental pick to chip away any excess Lightweight Hydrocal.

If there are any remaining rough edges or breaks in the terrain around the areas where rocks have been installed, they can be repaired by covering with small strips of Plaster Cloth or filling in with Lightweight Hydrocal or Mold-A-Scene Plaster. These products will also help provide any additional terrain blending that is needed.

TECH TIP

When casting rocks from Rock Molds, it may be desirable to create concave backs on the castings. This will make the rocks more lightweight and may help them to fit the curved contours of the layout.

To do this, pour a small amount of Lightweight Hydrocal into the bottom of the mold. Then use a paintbrush to stroke the Lightweight Hydrocal up the sides of the mold until it begins to set. The Lightweight Hydrocal should be 1/4" to 3/8" thick on the inside of the mold. Remove the casting carefully from the mold when dry.

MAKE YOUR OWN MOLDS

If you prefer to make your own rock molds, it is possible to duplicate the rocks in a particular part of the country or some rocks you happen to like. The molds can be made either at home or in the field, if there is the time to allow the Latex Rubber to set. In selecting rocks to mold, keep in mind that it will be difficult to work with castings which are very large as they will not fit onto the terrain shell easily. Note: national and state park areas do not permit the removal of any natural materials, including rocks, from the premises.

48

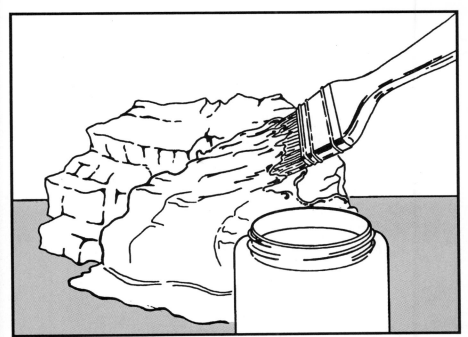

Make your own rock molds by painting layers of Latex Rubber onto whatever rocks you choose with an inexpensive synthetic fiber brush. Use three layers of Latex Rubber if only a few rocks will be made from the mold, and six layers plus a gauze or cheesecloth layer if many uses of the mold are planned. Allow each layer of Latex Rubber to dry before adding another.

If working with rocks in the field, begin by spraying the rock face with **Woodland Scenics Scenic Cement** and allowing it to dry. Scenic Cement is a water base ready-to-use matte-medium which dries clear. It will help solidify any loose talus or rock debris on an individual rock. The rest of the instructions for making a rock mold are the same whether working at home or in the field.

Using an inexpensive synthetic fiber brush, paint on a layer of Woodland Scenics Latex Rubber. Carefully push the Latex Rubber into all the cracks and crevices and do not leave air bubbles between the rock and the Latex Rubber layer. Allow approximately 30 minutes drying time for the Latex Rubber. Wash the paintbrush immediately with water, using a wire brush to help clean bristles.

Before applying a second layer, consider how much use the rock mold will get. If only a few castings are planned from an individual mold, we recommend three layers of Latex Rubber. Proceed with a second and third layer application of Latex Rubber in the same manner as the first layer.

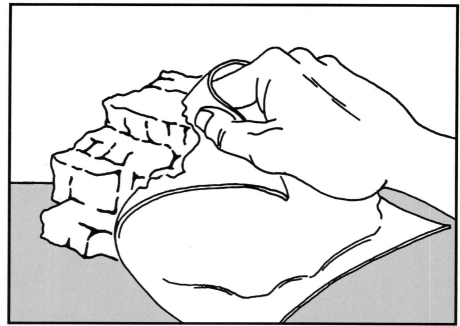

After the final layer of Latex Rubber has dried, carefully pull the mold off of the rock. This mold is thinner than the Woodland Scenics Rock Molds which are purchased preformed. To successfully make rock castings, support the mold in a box of sand or wadded up newspapers to hold it firmly in place while the Lightweight Hydrocal is poured.

Allow the proper amount of drying time after each layer and carefully peel the finished mold off the rock. The mold is now ready to use.

If your plans include a large number of castings from the mold, a more durable mold may be desired. You will want to use a layer of gauze or *cheesecloth* (available in fabric stores) and a total of six layers of Latex Rubber to make the mold thicker and more durable. Apply the second layer of Latex Rubber. While it is still wet, press in a layer of thin, non-stretchable material, such as gauze or cheesecloth, working it into all the cracks and crevices. Do not use a stretchable material such as nylon because it will allow the mold to distort. The third coat of Latex Rubber is painted on over the cheesecloth after the second layer is dry. The fourth, fifth and sixth layers are then added, allowing drying time between each layer. After the final layer has been added and dried, carefully peel the mold off the rock.

Notice that the Latex Rubber mold you have made does not seem to be as stiff as the highly detailed Woodland Scenics Rock Molds that are purchased. This does not lessen its ability to give excellent rock castings, provided some kind of support is placed under the mold when pouring Lightweight Hydrocal into it. Supply this support by placing the mold in a box of sand or wadded

up newspaper to hold it firmly in place and prevent distortion when the Lightweight Hydrocal is poured. With this support, the Latex Rubber molds can be used in the same manner as the preformed rock molds. If desired, some distortion of the rock mold can be created by its positioning in the box of sand or newspapers to provide variety in the rock castings.

REPAIR TERRAIN GAPS

While installing Tunnel Portals, Retaining Walls, Culverts, tunnel liners, and rock castings on the layout, some gaps may have been created between these items and the surrounding terrain shell. These gaps in the terrain should be repaired before continuing with coloring.

Rock and plaster castings should fit smoothly into the surrounding terrain without gaps and holes between castings and the underlying terrain shell. You can fill these gaps with Mold-A-Scene Plaster, strips of Plaster Cloth, or Lightweight Hydrocal. Use Plaster Cloth to fill a large gap around a Tunnel Portal or between rock castings. If there are small holes or cracks, use some Mold-A-Scene Plaster or Lightweight Hydrocal. Some contour changes can also be made at this time with Mold-A-Scene Plaster or Lightweight Hydrocal. Add these materials to the layout to build up the banks of a river or pond, put in terraces or berms, or enhance the height or mass of a mountain.

If you want additional Tunnel Portals, Retaining Walls or Culverts on your layout, use a hobby knife to cut into the terrain surface and create a space the appropriate size. Install the casting by attaching with Lightweight Hydrocal, Flex Paste, or white glue, depending on the underlying material. Then use some Plaster Cloth strips to make the casting fit snugly to the surrounding terrain.

Additional rock castings can be attached directly to the existing terrain shell. If the castings will jut out too far, cut into the underlying terrain material and recess the castings into the hillside. Strips of Plaster Cloth can then be applied around the casting to blend it into the terrain.

COLORING PLASTER CASTINGS

The plaster castings you place on a layout can include tunnel liners and rocks which you cast yourself plus the Tunnel Portals, Retaining Walls, and Culverts which you purchase ready made. All of these castings help to add realism and detail to the layout. But none of these castings will look realistic until they are colored. Color will make the layout come alive and begin to look real.

A young child would probably color the sky blue, the sun yellow, and the leaves green. The real world is not this perfect, but rather it blends colors

together in lighter and darker shades and mixtures of color. This *mixing* and *blending* will create the most realistic look for the layout. It may sound difficult, like something only an artist would be able to do. But do not give up. It can be much easier than it sounds. First of all, what is needed is some information about the actual colors that appear in rocks.

Rocks contain a variety of different colors. If you are modeling a particular area of the country, you may want to familiarize yourself through photos or books with what appears there. If your layout is not based on a particular prototype area, you will be more interested in creating realistic looking rocks with colors which look natural.

Many ideas about color are available by simply observing. Look around and learn by observing the colors in your area, being particularly careful to note the imperfections. Is concrete just gray, or does it sometimes appear to have a brown or black tint? Does it have cracks or spots of oil that are darker than the rest? What about the timbers in a tunnel portal? Are they brown or gray? Are there dark and light areas caused by weathering or other substances on the timber? By sharpening your powers of observation you will be able to help yourself create realistic color on the layout.

The **Woodland Scenics Earth Color Liquid Pigments** system includes appropriate colors for all terrain features. There are earth tones for rocks and earth; warm grays for concrete, asphalt, and rocks; and undercoats for green and earth Turf areas. The Pigments are designed specifically for model use, and come in natural earth tone colors which can be difficult to find. One feature which makes the Liquid Pigments unique is that they contain pigment only, with no sealer. In some instances this is all that is needed. And it makes it possible to wash the Pigments off if you do not like what has been colored. When you want to seal the color in, just spray with or brush on Scenic Cement to complete the painting process. Then the colors will be permanent.

The Pigments are nontoxic and water soluble, making them both safe to use and easy to clean up. The Pigments are highly concentrated. Use them like an opaque paint, or thin them with water to make a stain or transparent wash. The Liquid Pigments can be used on most surfaces including plaster, Plaster Cloth, foam, paper, papier-mache, and wood. This versatility helps make the Pigments economical because one product can be used for many purposes.

Woodland Scenics Earth Color Kit contains one small bottle each of eight colors plus mixing tray, foam applicator, and complete instructions. Four-ounce replacement bottles of these eight Pigments are available individually, as are the 8-oz. bottles of Green Undercoat and Earth Undercoat. The Earth Color Kit is a very convenient and economical way to get started with all of the items needed for coloring plaster castings. With the complete selection of colors, it is easier to mix and blend for the most realistic result. Other

paints may be used for coloring plasters but they will not blend in exactly the same manner as the Earth Color Liquid Pigments. The coloring instructions that follow are for use with the Earth Color Liquid Pigments System.

Earth Color Liquid Pigments can be mixed into wet plaster to color it. However, color added to plaster tends to be an even pastel shade that is reminiscent of ice cream. Therefore, we like to add color after plaster has hardened because it looks more natural.

Before beginning to color the castings on the layout, practice using the colors and the coloring techniques on some surplus castings. This will provide some experience in blending the colors, and you will learn how easy the system is to use. Check the Color Formulas on Page 66 and the color samples on Page 67 for some ideas on rock coloring.

An important factor when coloring plaster castings is the absorbency of the plaster surface. Some plaster surfaces are very absorbent and accept color washes and stains readily. Some surfaces are non-absorbent and will not accept washes and stains but must be painted with opaque painting techniques. The surface of plaster castings may vary from extremely absorbent to non-absorbent. The Liquid Pigments can vary from transparent wash to opaque coat as required to color any absorbency condition.

Dry plaster absorbs more readily than wet plaster. Therefore it accepts washes more readily and appears more intense, or darker. If a plaster casting is completely saturated with water, it will not accept washes or stains. Different castings, even different spots within the same casting, can have different levels of dryness which will make them absorb color differently.

Different products like Lightweight Hydrocal, Mold-A-Scene Plaster, Plaster Cloth and other plasters will absorb color differently and may impart some color of their own.

The porosity of plaster surfaces can vary from highly porous to nonporous. The more porous the surface the more readily it will absorb color washes or stains. Nonporous surfaces may not absorb washes or stains at all. Marring, rubbing, smoothing out, or polishing can close the pores on the surface of a casting, making it less absorbent. Materials such as Scenic Cement, Flex Paste, white glue and super glue will seal plaster surfaces and require coloring with opaque painting techniques. Be as careful as possible to avoid marring, rubbing or polishing plaster surfaces. Avoid getting Scenic Cement, Flex Paste, white glue or super glue on surfaces you want to color with a wash or stain.

The Earth Color Liquid Pigments can be diluted into thin washes, used undiluted, or mixed to any number of dilutions in between these two extremes. Liquid Pigment colors can be premixed before applying to create

custom colors that match colors of rocks in a specific locale. Color can be combined on the mixing tray if a small amount is needed or in a jar or Scenic Sprayer. The Scenic Sprayer is especially convenient because it has the ounce markings noted on it.

Staining With Washes: A wash is created by adding large amounts of water to Liquid Pigment. The more water the lighter the wash. The more pigment the stronger (more intense) the wash. Washes are intended to be transparent coatings so even light washes on plaster can be made to look darker by applying an additional wash to the plaster after the previous wash has dried. Several coats of one color of wash will provide different intensities of color. Several transparent washes of two or three different colors will create new shades of color where the washes of the two or three different colors overlap. This wide range of intensities and shades of color is very natural and realistic looking.

If a wash is too dark to begin with, it will not be very transparent and the wide range of shades and intensities will not develop. Therefore, we recommend diluting the Liquid Pigments to a very light wash before beginning. More pigment can always be added if a stronger wash is desired later. Some colors are more intense and should be diluted with more water than other less intense colors.

We recommend the following Liquid Pigment dilutions to create a light wash which is virtually foolproof. The washes can be mixed in a Scenic Sprayer or any convenient container. Stir or shake frequently when using.

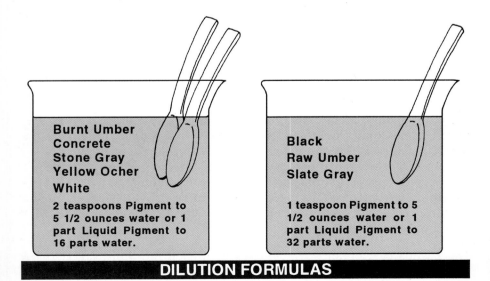

Burnt Umber
Concrete
Stone Gray
Yellow Ocher
White

2 teaspoons Pigment to 5 1/2 ounces water or 1 part Liquid Pigment to 16 parts water.

Black
Raw Umber
Slate Gray

1 teaspoon Pigment to 5 1/2 ounces water or 1 part Liquid Pigment to 32 parts water.

DILUTION FORMULAS

<u>Coloring Tunnel Portals, Retaining Walls, and Culverts:</u> These plaster castings are usually easier to color before they are assembled. Lay the pieces on paper towels with enough room between pieces so that the Liquid Pigment can get to all side areas of each piece. While several different coloring methods and color combinations can be used, we recommend the following as being the easiest and producing the most consistent results. All coloring is done with the washes described above.

1. For Concrete or Masonry pieces—Spray these pieces first with the Concrete wash then with an overcoating of Black wash. For a darker color, repeat the process.

2. For Cut Stone or Random Stone—Spray on a layer of Stone Gray wash followed by Black wash repeating more layers until the color is dark enough. For an even darker color, allow the castings to dry between coatings of Pigment. Several colors of washes can also be used on Cut Stone or Random Stone if you prefer.

3. For Timber pieces—Spray on a layer of Burnt Umber wash followed by Black wash. Repeat these layers as many times as needed allowing the castings to dry slightly between each spraying.

If some white spots remain or you want additional detailing with color, dip a brush in water and then in pure Pigment. Daub on the areas which have remained white and blend into the previous coloring. Additional spots of highlighting color can also be added in this way.

When you are satisfied with the color, allow the castings to dry, then spray or daub on Scenic Cement to seal the color. After the Scenic Cement has dried, an additional overspray of a more concentrated Black wash can be added if desired to emphasize cracks and crevices. Repeat the Scenic Cement application to set this color.

<u>Techniques for Coloring Rock Castings:</u> There are many techniques available for coloring rock castings. We prefer the *"leopard spot"* technique where spots of various colors of washes are randomly placed on the rock castings, then blended together with an overcoat of the dominant rock color. This technique provides the most variations of color. Another technique which may be particularly appropriate for modelers who have never colored rock castings is to apply an initial light coating of the

TECH TIP

Rocks in many areas are made up of layers of different colors. These layers can be modeled by using a paint brush to apply the colors in uneven horizontal stripes. Blend all the colors together with a thin wash of Black Pigment.

dominant rock color, then use other colors in a leopard spot pattern to add variations.

The following directions explain the "leopard spot" method of coloring rock castings:

1. Consult the color chart to select a dominant rock color and as many secondary colors as desired. See Page 146.

2. Mix the diluted washes of these colors as listed in the above chart.

3. The washes may either be squirted on with a Scenic Sprayer (adjust the setting to squirt instead of spray) or daubed on with a foam applicator or acrylic brush.

4. Begin with one of the secondary colors. Squirt or daub it in random spots covering approximately one third of the rock casting if you are using a total of three colors; one fourth of the casting if you are using four colors; etc. Don't try to cover all the white.

5. Apply the second color and squirt or daub on random spots of color in a similar amount.

6. Continue with this procedure using all the selected secondary colors and the dominant color. You may want to squirt or daub additional overlapping layers of one or all of the colors being used. Allow the washes to run and overlap on the casting.

7. Use the dominant color and spray or daub on a flood coating which covers all areas of the casting.

8. Because of the porosity differences in plasters and the possibility of marring before the casting is colored, there may be areas which do not accept the washes and remain very light or white. Touch up these spots and areas that don't accept washes with more concentrated Liquid Pigment, slightly thinned with water, or pure if necessary. Daub this color on with a brush or foam applicator. If the color is too dark, dilute it or wash it off by spraying with water from the Scenic Sprayer.

9. Allow the rock casting to dry, then spray or brush on Scenic Cement.

10. When the Scenic Cement is dry, spray or daub on a more concentrated Black wash to emphasize the cracks and crevices.

If too much water seems to be accumulating on the layout, use paper towels to help soak it up. A small corner of the paper towel can be rolled into a point to reach into cracks and crevices to soak up excess water in these areas.

Repainting Previously Colored Castings: Plaster castings or rocks made of material other than plaster can be recolored if they are first brought back to a white base color. Use the White Pigment and brush it on the previously colored castings or rocks to cover their color.

Use the White Pigment full strength to achieve this. Allow the Pigment to dry, then spray on a coating of Scenic Cement to seal the White. When this dries you are ready to apply coloring. Wet a foam applicator or synthetic fiber brush with water, then dip it in Liquid Pigment which is full strength or a heavy concentration. Daub on the castings. Apply spots of various colors in the leopard spot pattern and allow them to mix and blend by lightly spraying with water from the Scenic Sprayer as you add Pigment. When the color is satisfactory, allow the castings to dry, then spray with Scenic Cement to set the color. An additional coating of a more concentrated Black wash can then be added to emphasize the cracks and crevices. This can be either sprayed or daubed on. Spray again with Scenic Cement when this coating is dry.

Removing Liquid Pigment: Should you decide you do not like the coloring you have done, the Liquid Pigments make it possible to remove color which has not been sealed with Scenic Cement. Simply *flood-spray* the castings with hot salt water (1 tsp. salt in 6-oz. water). Wait one minute and spray again if needed to remove color. Now you are ready to begin the coloring process again.

Sealing the Color: When you are satisfied with the color on the castings, allow them to dry. Then spray or brush on a sealing coat of Scenic Cement and allow it to dry. The color will now be permanent.

<u>Flyspecking:</u> Additional textures and realsim can be added to rock surfaces with a *flyspecking* technique. Mist the rock surfaces lightly with water. Bend a sheet of paper into an L-shape, placing a small amount of Soil Turf on the horizontal section of the paper. Gently puff air down the vertical side of the paper, blowing only a small amount of the Turf onto the rock surface. This adds additional detail to rock surfaces for more realism. It also adds an additional texture suggesting holes and porosity in the rocks and suggests soil which may have collected on the rock. If you have added too much Turf, brush it off and begin again. When you like the effect, mist the rock surface lightly with Scenic Cement to hold the flyspecks of Turf in place.

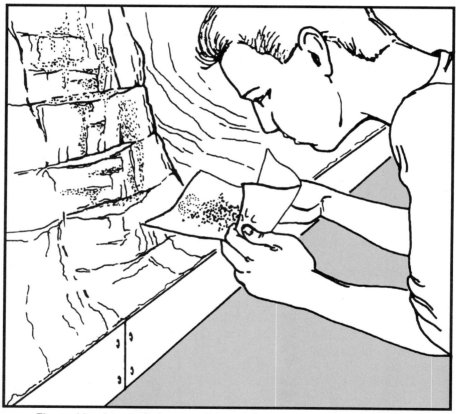

Flyspecking is a technique used for adding texture and realism to rock surfaces which have been colored. Use a Scenic Sprayer to lightly mist the rock surfaces with water. Bend a sheet of paper into an L-shape and place a small amount of Soil Turf on the horizontal section of paper. Lightly puff air down the vertical section of the paper to blow a little Turf on the rocks. This adds additional detail to rock surfaces for more realism. If you have added too much Turf, brush it off and start over. Permanently attach the Turf with a light spray of Scenic Cement.

You will experience some differences in the way different materials (high density plaster castings, Lightweight Hydrocal, Mold-A-Scene Plaster, Plaster Cloth, etc.) accept color. Do some experimentation on excess material to find the particular mix of Pigment and water which works best. The age, and therefore the dryness, of materials will also affect coloring. Again, experiment on surplus materials to determine what works best.

The Earth Color Liquid Pigments can also be used to tint Woodland Scenics Flex Paste and Scenic Cement. Mix either of these products with a small amount of Pigment until the desired color is obtained. Talus is another product which can successfully be colored with the Liquid Pigments. Talus will look the most natural when its color is a close match to the rock castings. To color Talus, diluted Liquid Pigment can be squirted, dribbled or daubed on Talus after it has been attached to the layout. Use the same colors of Liquid Pigment as are used in coloring the rock castings.

Since the Liquid Pigments are water soluble products, clean up of brushes, mixing tray, jars, and hands is fast and easy with soap and water.

THE SCENERY KIT

The Scenery Kit by Woodland Scenics helps you learn by doing. It gives you practice in using many of the products and techniques discussed in this chapter. The Scenery Kit contains complete instructions plus all the terrain and landscape products needed to build a 10" X 18" display diorama. It is the simple and easy way to learn and practice these techniques right now even if you do not have a layout. See Page 132 for a photo and complete listing of The Scenery Kit contents.

This graduated illustration shows the progressive phases of terrain building. At left is the open benchwork of the layout with a raised sub-roadbed. A terrain base of corrugated cardboard is added to hold the terrain materials. Next, newspaper wads and masking tape have been used to build up some rolling terrain. Plaster Cloth is then added to form the hard terrain shell over

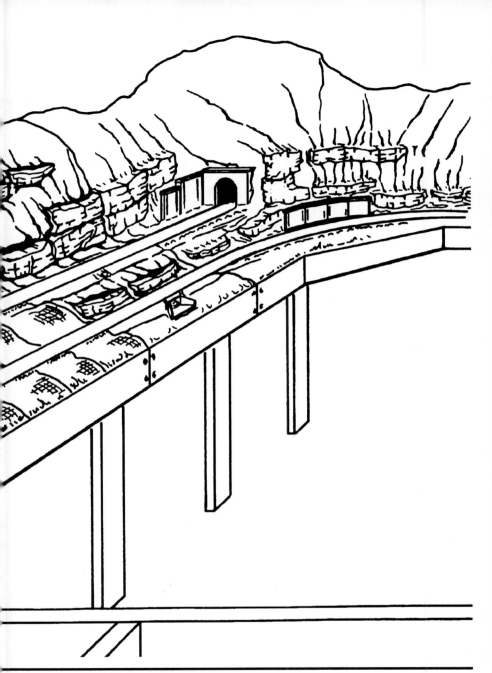

the newspaper wads. The spaces for Culverts, Retaining Walls, and Tunnel Portals have been built in and these castings have been installed. Rock outcroppings are the final terrain feature to be added. Plaster Cloth and Mold-A-Scene Plaster have been used to fill in any open areas around the outcroppings.

CHAPTER SUMMARY

NEWSPAPER WAD OR CARDBOARD STRIP CONTOURS

Create the terrain contours on the layout. Wad up sheets of newspaper and stack them on the layout to form the shapes of mountains, hills, and land contours. Move the newspaper wads around to experiment with different contours in various locations. Use masking tape to hold the newspaper wads in place when you reach a satisfactory appearance. In some situations, such as high mountains or joining two different levels of track, use cardboard strips to create the contours. To review this section, see Page 25.

ADDING PLASTER CASTINGS

Plaster castings for tunnel liners, tunnel portals, and retaining walls should be fitted to the layout contours before the terrain shell is completed. Tunnel liner castings permit easy and foolproof tunnel construction. Use the Woodland Scenics Tunnel Liner Form to cast as many sections as needed from Woodland Scenics Lightweight Hydrocal. Assemble with strips of Woodland Scenics Plaster Cloth creating a hinge so the tunnel can be opened. Woodland Scenics Tunnel Portals and Retaining Walls make the railroad more realistic and interesting. These castings are purchased preformed. Assemble the castings you will use and install on the layout using Lightweight Hydrocal as an adhesive. Woodland Scenics Culverts may be assembled and installed before the terrain shell is created or later when rock castings are added. To review this section, see Page 37.

CREATING A TERRAIN SHELL

There must be a hard terrain shell covering the newspaper wad or cardboard strip contours to which rock castings, stains, and landscape materials can be attached. This is accomplished by covering the newspaper wads or cardboard strips with Plaster Cloth. Dip the Plaster Cloth in water and apply, overlapping each strip 50% on the previous strip and 50% on uncovered area. Extra strength can be obtained by using another layer of Plaster Cloth or applying a layer of Lightweight Hydrocal. To review this section, see Page 31.

ADDING ROCK OUTCROPPINGS

Cast rocks for rock outcroppings with Lightweight Hydrocal using several different Woodland Scenics Rock Molds to create a variety of rock faces on the layout, or by making custom molds with Woodland Scenics Latex Rubber. Carve and reshape the rock edges to fit as required. Attach the rocks to the terrain shell using either the brick method of installation with

Lightweight Hydrocal as an adhesive and filler between rocks or the shingle method of attaching rocks while the Lightweight Hydrocal is still wet. To review this section, see Page 42.

REPAIR TERRAIN GAPS

Repair any gaps or breaks in the terrain contours by using Woodland Scenics Plaster Cloth to repair large areas. Use Mold-A-Scene Plaster or Lightweight Hydrocal to repair small problems or change the contouring. To review this section, see Page 51.

COLOR PLASTER CASTINGS AND ROCK CASTINGS

Use the Woodland Scenics Earth Color Liquid Pigments in diluted form to color the plaster castings and rock castings. Dilute the Liquid Pigments with water in the ratio of 1 part Pigment to 32 parts water for Black, Slate Gray, or Raw Umber, and 1 part Pigment to 16 parts water for all other colors. This dilution creates a wash which can be squirted, sprayed, or daubed on. Apply color to Tunnel Portals, Retaining Walls, and Culverts before assembly. Squirt, spray, or daub on Concrete followed by Black for Concrete or Masonry items, Stone Gray and Black for Cut Stone or Random Stone items, and Burnt Umber and Black for Timber items. For rock castings, review the color formulas on Page 66 and color swatches on Page 146. Choose a base color and one or two secondary colors. Squirt or daub the colors on in a leopard spot pattern. Overspray the entire casting with the base color. Allow to dry, and spray on Scenic Cement to set the color. Then apply a Black wash to emphasize cracks and crevices. To review this section, see Page 51.

This series of photos shows the progression of terrain building on a layout. 1. Begin with the terrain base, Trackbed, and track already in place. 2. This photo shows a number of steps. The beginning newspaper wads are in place and castings from the Tunnel Liner Form have been made and installed. The Tunnel Portal and Retaining Walls are trial fitted with the tunnel liner. Finally, a Culvert is located below the track. 3. Here the newspaper wad terrain over the tunnel liner has been completed. Plaster Cloth is being used to cover the newspaper wads in the area of the Culvert. 4. The entire contour area has now been covered with Plaster Cloth to form the hard terrain shell. 5. Rock castings are trial fitted in place and the Tunnel Portal and Retaining Walls have been colored, assembled, and installed. 6. The rock castings have been attached using Lightweight Hydrocal as an adhesive. Mold-A-Scene Plaster is being used to fill in open areas around the rock castings, Retaining Walls, and Culvert. 7. The Earth Color Liquid Pigments are used to color the rock castings.

COLOR FORMULAS

Apply multiple layers of Earth Color Liquid Pigments to create infinite variations in rock color. These samples show some possibilities. Use excess pieces of castings and experiment to find the combinations which look best for the area you are modeling. Use the "leopard spot" technique to create overlapping layers of transparent colors.

Sample 1—The coloring on this casting was all done with Black Pigment. Squirt on leopard spots of Black wash in the ratio of one part Pigment to 32 parts water. Dry slightly and then squirt on another leopard spotting of Black wash. Dry slightly then overspray the entire casting with Black wash. Allow to dry and spray or brush on Scenic Cement to set the color. Finish with an overall spray of Black wash which capilliaries into the cracks and crevices to accent them. When this has dried, spray or daub on Scenic Cement to set the color.

Sample 2—Squirt on leopard spots of Stone Gray and Black washes. Repeat this leopard spotting with Stone Gray and Black hitting different spots with the colors. Flood spray on the dominant rock color of Stone Gray. Allow to dry and spray or brush on Scenic Cement to set the color. Finish with an overall spray of Black wash which capilliaries into the cracks and crevices to accent them. When this has dried, spray or daub on Scenic Cement to set the color.

Sample 3—This casting was squirted with leopard spots of Yellow Ocher, Burnt Umber, Raw Umber, and Slate Gray washes. The colors are then repeated with the spots falling in different areas. Apply a flood spray of the dominant rock color which is Raw Umber. Allow to dry and spray or brush on Scenic Cement to set the color. Finish with an overall spray of Black wash which capilliaries into the cracks and crevices to accent them. When this has dried, spray or daub on Scenic Cement to set the color.

Sample 4—Achieve this type of coloring with leopard spots of Burnt Umber, Stone Gray, and Slate Gray repeated a couple of times. The selected dominant color is Burnt Umber so squirt on a flood spray of this wash. Allow to dry and spray or brush on Scenic Cement to set the color. Finish with an overall spray of Black wash which capilliaries into the cracks and crevices to accent them. When this has dried, spray or daub on Scenic Cement to set the color.

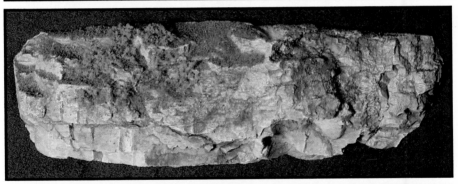

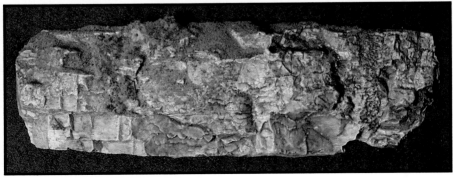

The Earth Color Liquid Pigments can be used to color or recolor almost any surface. This photo series shows the method used to recolor these surfaces. First, brush on an opaque layer of the White Pigment in full strength concentration. Allow this to dry and spray on a coating of Scenic Cement. When this dries, you are ready to recolor. Dip a foam applicator in water and then into full strength Yellow Ocher Pigment. Daub on the Yellow Ocher in a leopard spot pattern.

Dip the foam applicator in water and then into full strength Raw Umber Pigment and daub on in the leopard spot pattern. Then daub on an overall covering of Raw Umber which is the dominant color.

After the initial coloring has dried, spray or brush on Scenic Cement to seal the color. Then overspray with a Slate Gray wash in a 1:32 ratio. Allow this color to flow into the cracks and crevices to highlight them. The result is a completely recolored rock face which features blended colors for the most realistic look.

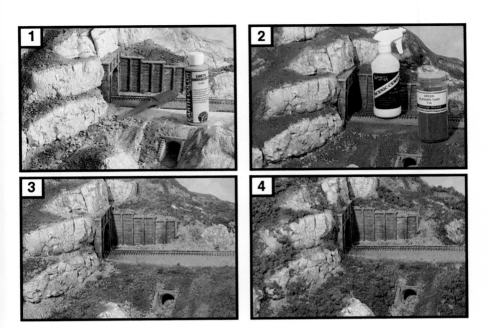

This series shows the development of an area with the Woodland Scenics Landscape System products. 1. The open ground areas have been painted with Earth Undercoat. 2. These areas have now been covered with Green Blend Turf which is attached with Scenic Cement. 3. Texturing is added with the application of Coarse and Extra Coarse Turf and Talus. 4. Texturing continues with Clump-Foliage and Foliage Clusters used as bushes and Foliage material stretched to form vines and ground cover plants. 5. The completed scene has both Field Grass and trees added to it.

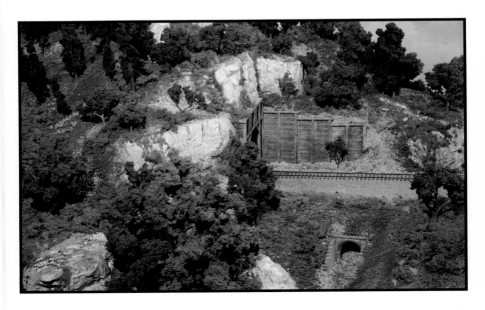

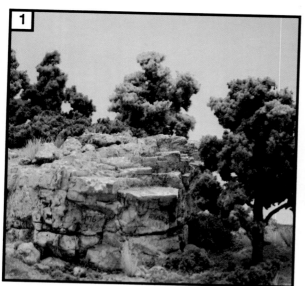

1. An example of a rock outcropping occurring in a non-mountainous area. Outcroppings, embankments and boulders can occur in almost any terrain. 2. These trees illustrate the size differences which can occur within the same tree species. Be sure to use a variety of tree sizes and shapes on the layout. 3. Some of the ways vines grow on trees and buildings can be seen here. They can also be used on bridges, Tunnel Portals, Retaining Walls, and telephone poles as well as on the ground. 4. Dead trees can be used in a number of ways. They could be used in or near a swampy area, as part of a burned over area, or just scattered out among live trees. 5. This photo shows a good blending of scenery materials. The towering rock wall is created with castings from various Rock Molds. Talus is spread down the mountain valley and below the track. Foliage Clusters, Clump-Foliage, Turf, and Field Grass provide the ground cover.

Clumps of yellow Field Grass and trees just beginning to turn yellow show some of the ways to indicate seasonal changes on a layout. In this photo the coloring of the landscape materials announces that autumn is on the way.

Photo and model by Peter Watson.

Water areas in the form of streams, rivers, ponds, lakes, ports, and standing water are easy to install on a layout with Woodland Scenics E-Z Water. Be sure to use Turf, Clump-Foliage, Foliage Clusters, Foliage material, Field Grass, Talus, and trees to detail the edges of water areas.

In the top photo, Woodland Scenics landscape and terrain materials make it possible to easily create realistic looking scenery for any prototype area. The bottom photo uses Rock Molds and Talus to create steep cliffs on both sides of the track. Turf, Clump-Foliage, Foliage Clusters, Field Grass, and Realistic Trees complete the look of a heavily wooded hillside.

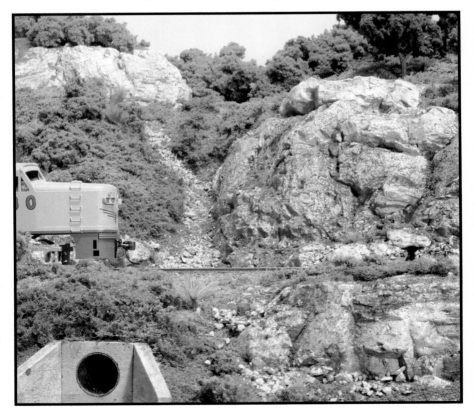

These photos show the types of scenes created by combining Design Preservation Models buildings and modular building sides with Woodland Scenics landscape and terrain materials. Both industrial and commercial buildings are available from Design Preservation Models in easy to build kit form. Use the modular building sides to create an unlimited number of buildings.

Chapter III

LANDSCAPE

In this chapter the goal is to learn the easiest methods of adding natural looking landscape materials to the layout contours. Both color and texture can be added to a layout in the basic steps presented in this chapter.

By now your layout should be well underway. The idea for the layout has been created, scale and gauge determined, benchwork has been built, track and wiring are installed, you have contoured the terrain areas, and colored the rocks and plaster castings. The next step in building a realistic model railroad is landscaping—ground cover, ballast, bushes, grass, trees, water, and roads. These *landscape* items make the railroad look more realistic. They are also important for camouflaging some construction flaws and for providing view blocks to make the railroad appear larger.

Chances are good that when you look out your window, you first notice landscape items. Unfortunately, this tendency to readily observe landscape features is not as easily translated to the models we build. Few, if any, model railroads have too much landscape material on them. In fact, many model railroads are noticeably lacking in landscape materials and tend to look barren and unfinished.

The choice of materials to use for landscaping a model has gone through an evolution since the early days of model railroading. In the early days the only available materials were natural ones—sticks, rocks, weeds, sand, and dirt. There are a number of drawbacks to these materials such as the difficulty of finding them in the proper scale, their deterioration over time, and the attraction some of them have for insects and rodents.

The current preferred method of creating landscape on a layout is to use commercially produced products for landscaping. Hobby shops carry a variety of landscape materials in several colors and *textures* made from

various materials. One key to making selections is to look for authentic colors and textures. Remember that in the real world general landscape colors are somewhat muted with patches of color and textures that blend together. Select landscape materials that reflect this reality rather than the bright or even gaudy colors you may see available. Look for products whose colors complement each other well since the landscape products will be intermingled throughout all parts of the layout.

The Woodland Scenics Landscape System products provide you with realistic colors and textures for modeling all parts of the country in different seasons of the year. Because it is a complete system, the colors and textures coordinate, making it possible to mix, match, and blend with complete assurance that the finished product will look natural and authentic. The hard work of finding natural colors that will mix and blend together is done for you, leaving you free to concentrate on other areas.

In adding landscape material to a layout there are few absolute rules about what order to use in proceeding. Obviously, the base ground cover needs to be put on before a second layer can be added. But whether you apply ballast before or after ground cover, or whether you pour water before or after adding grasses are matters of individual preference. The landscape materials can be seen as raw materials to be applied in whatever order you feel is the most workable. The progression presented in this chapter is one method of working. We suggest that you first read the entire chapter, then alter the progression if needed to fit your layout and your preferred method of working.

BALLAST

One area where landscaping can begin is *ballast*. All railroads use it under and around ties to provide stability for the ties and provide a means for water drainage. Ballast is simply rock that is broken up into specific sizes, and spread under and between ties. Different kinds of rock are used by railroads in various parts of the country for ballast. Primarily, this selection is a function of cost. Railroads use what is available locally or what can be brought in from nearby due to the cost of moving tons of rock.

Ballast can be applied at any time after the track is laid. Since it helps to solidify track and keep it from moving,

TECH TIP

Volume, not weight, is the most important factor in finding the best value in ballast. On a model, the weight of ballast is relatively unimportant since it is really the spikes and the ballast adhesive which hold track firmly in place. Woodland Scenics Ballast is economical as well as offering a realistic look and selection of colors.

you might want to add ballast even before completing the terrain contours. Or, it could be the first landscape item added after the contours are completed.

Woodland Scenics Ballast is made in several different colors and sizes to provide the variety needed for most areas of the country and most scales. Select the color of Ballast desired. Be sure to consider scale when selecting Ballast. Very large rock would not fit in well around ties and very small rock would wash away.

A very useful tool for storing and applying ballast and other landscape products is the **Woodland Scenics Scenic Sifter**. This is a clear plastic bottle that comes with two

interchangeable snap-on sifter caps with openings of different sizes. *Scenic Sifters* allow you to see the product inside and select the size of opening needed for dispensing the product. By having one bottle for each product being used, you will be able to quickly and easily select the product and the color needed for the area you are working on.

There are two methods of applying Ballast, either of which will work successfully. The first method of applying Ballast is with Scenic Cement. Using a Scenic Sifter, pour a small quantity of Ballast down the middle of

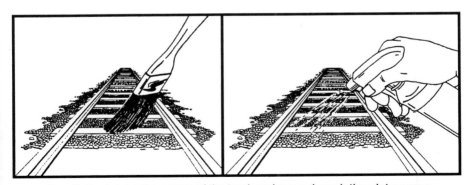

Pour Ballast down the center of the track and use a dry paintbrush to sweep off ties and rail. Lightly mist with Scenic Cement from a Scenic Sprayer then thoroughly soak with Scenic Cement. Or mix the Ballast with Dry Ballast Cement before placing it on the track. Sweep off ties and rail, and spray with wet water to attach the Ballast. Clean off the track with an eraser type track cleaner when the Ballast is dry.

the track. Use a dry paintbrush to smooth out the Ballast and sweep off ties and rail. All of the rail and the tops of the ties should be free of Ballast. Lightly mist with Scenic Cement from the Scenic Sprayer adjusted to a very fine spray to help prevent Ballast from floating. Then thoroughly soak the Ballast with Scenic Cement. Allow the Ballast to dry.

A second method is to mix the Ballast with **Woodland Scenics Dry Ballast Cement** in the ratio of two parts Ballast to one part Ballast Cement. Apply the Ballast mixture from the Scenic Sifter down the center of the track. Smooth out the Ballast and sweep off ties with a dry paintbrush. Mix wet water in a Scenic Sprayer and gently saturate the Ballast. Allow it to dry. Caution: Dry Ballast Cement is a strong sensitizer that may cause skin irritation. In case of contact, flush with water.

Although either method of applying Ballast will work, we recommend the first method using Scenic Cement as an adhesive. This is the most inexpensive method of applying Ballast.

> ## TECH TIP
>
> Ballast colors are sometimes unique to particular parts of the country because of the rock available there. Duplicate these unique colors by coloring the Light Gray Ballast with paints from the Earth Color Liquid Pigments or latex paint. Dilute the Pigment with water to a thin wash in the Scenic Sprayer. Place the Ballast on paper towels and spray with the Scenic Sprayer until the appropriate color is achieved. Air dry or, for quick drying, place the Ballast in an oven.
>
> One example is the pink granite ballast found in some areas of the country. Use Light Gray Ballast and a red latex paint.

After the Ballast has dried, remember to clean off the track with an eraser-type track cleaner to remove any traces of Ballast or Scenic Cement. If the track is not carefully cleaned, power may not get to the engines or derailments could occur when the wheels come in contact with material on the rails.

Ballast can be used in other areas on the railroad besides track. Use it around mining operations, in rail yards, and wherever graded rock would appear. Ballast can be used as a load in a hopper car either coming from a mine or as a railroad work car.

One product that is sometimes difficult to model is coal. **Woodland Scenics Coal** is a natural product and therefore solves the problem of not looking real. It comes in two sizes, the smaller Mine Run and larger Lump Coal. Coal is applied in the same manner as Ballast with either Scenic Cement sprayed directly on the Coal, or the Dry Ballast Cement and wet water. Use mounds of Coal around mines or coaling facilities to add realistic detail, or as a load in a hopper.

TALUS (ROCK DEBRIS)

Due to cycles of freezing and thawing, erosion by water and wind, and human impact on the environment, rock is constantly breaking down to smaller chunks known as talus or rock debris. Talus is seen around the base of mountains and rock cuts, in mountain valleys, around retaining walls and tunnel portals, along the bottom of culverts, and in and beside rivers and streams. Because talus is primarily created by the forces of nature, it comes in all sizes from very small rock to fairly large boulders. The mountain and water areas on the layout will not really be complete without the addition of some talus. Since talus is the rock from the local area that has broken up, a fairly close match to the color of the rocks being modeled is needed for realism.

TECH TIP

In mountainous areas, Talus would frequently be seen in the form of Talus cones. These occur at the base of cliffs where Talus has fallen from above to form a cone with the larger rocks at the bottom and smaller rocks forming the cone around and above them. Look for a Talus cone in the illustration on Page 79.

Woodland Scenics Talus comes in a number of sizes and colors to blend with the coloring of the mountains. Or, if you prefer, the Natural Color Talus

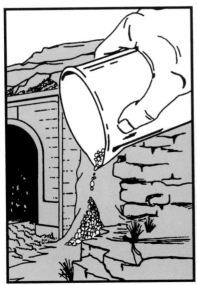
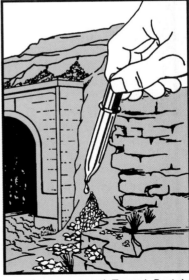

Use a combination of sizes of Talus and pour around Tunnel Portals, Retaining Walls, Culverts, below rock cliffs and rock outcroppings, in stream and river beds, in mountain valleys, and wherever there is a road or rock cut. Attach the Talus with a 50% white glue and 50% water mixture.

can be colored with the same Earth Color Liquid Pigments used on the rock castings and other rock areas. Attach the Talus to the layout as described in the next paragraph. After it dries, color it by daubing or spraying with diluted Liquid Pigment in the same manner described in Chapter II for coloring plaster castings.

Attach Talus to the layout by first spraying the area where it is to be placed with Scenic Cement. Use a combination of sizes of Talus in an area, with the smaller sizes on the bottom and larger sizes on the top. The boulders which make up the Extra Coarse Talus will need to be individually placed. Spread the Talus, beginning at the tops of hills and letting the Talus make its own natural path down the mountain. Add more Talus of different sizes in these pathways as well as around tunnel portals and retaining walls, around the bottoms of cliffs, and along the sides of streams and rivers. Place some more Fine Talus on the tops of Talus areas for the most realistic look. Attach the Talus by misting first with wet water. Then use an eye dropper to drop on a mixture of half water and half white glue with a drop of liquid soap. The glue and water mixture will dry clear. See Detailing Landscape Section on Page 106 for suggestions on adding detail to Talus.

ROADS

Roads are very important features of nearly any landscape. They can be added to your layout at this time. In the countryside between towns, roads were frequently built parallel to railroad tracks. In mountainous areas, roads generally follow the valleys and divides rather than climbing to the top of each mountain. In towns, roads are both parallel to track as well as crossing track to provide access to businesses and industries for workers and customers.

You will probably want to add a number of roads to the layout to give it a more realistic look. Remember that roads, like railroad tracks, are built for a purpose. They connect towns, provide access to industries, and give people a route to get to their homes. When you design roads, you must also design places to put the cars and trucks that travel on them. So be sure to include parking areas by houses and industries.

When the earth contours are prepared with newspaper wads and Plaster Cloth, determine the locations for roads and make sure the road base is smoothed out in the proper width for your scale. Roads can also be added later on if a new industry or mine is built, or changes are made in the terrain contours. When a road is added to an existing layout, you may need to create the flat level surface where the road will run. This can be sculpted with Mold-A-Scene Plaster or prepared with a strip of cardboard cut in the proper width and covered with Plaster Cloth or Lightweight Hydrocal. Surface materials are then added on top of the Mold-A-Scene, Plaster Cloth, or Lightweight Hydrocal.

There are several types of roads that can occur on a layout depending on what type of geographic area, terrain, and time era are being modeled. In many areas and time frames, dirt roads and paths are appropriate. To construct these types of features, see the section of this book on Low Ground Cover which covers the type of surface material used.

Gravel roads are important in many railroad areas, particularly in rail yards. In the larger scales, Fine Ballast is appropriately sized for the gravel. Select a suitable color for the area. Spread a layer of Ballast on the road base and smooth it out with a dry paintbrush. Spray gently with Scenic Cement as an adhesive. While the Ballast is still wet, add some detail by dragging the handle of a hobby knife through the Ballast to create some indentations for tire tracks and ruts. You may want to sift a little Woodland Scenics Turf on top of the Ballast and let it collect in the ruts and tire tracks.

If you are building in the smaller scales, gravel roads can be made by painting the roadbed with Concrete Pigment from the Earth Color Liquid Pigments. While the Pigment is still wet, very lightly sprinkle on some Earth Fine Turf.

To make a concrete or asphalt roadway, first "pave" the road area with a strip of Plaster Cloth, cut to the proper width for the scale. Use some extra Plaster Cloth or Mold-A-Scene Plaster if needed to build up banks, intersections, or grade crossings. Then cover the Plaster Cloth with Flex Paste or Lightweight Hydrocal to make a smooth finish. If needed, the roadway can be sanded for an even smoother surface. Continue by applying the Earth Color Liquid Pigments full strength from the bottle, in Slate Gray for asphalt or Concrete for a concrete roadway. When the Pigment is dry, use a hobby knife to "draw" in the sections of concrete or cracks in the roadway.

Parking areas beside homes or businesses can be surfaced with dirt, gravel, rock, concrete, or asphalt. Build them in the same manner as the roads. Be sure to leave some ruts, cracks in concrete, and tire tracks.

GROUND COVER

Ground cover is the generic term which we use for the dirt and soil as well as all of the plants and low growth that are seen both in forests and in open areas. Low ground cover includes the base coloring and smallest grasses and plants. Medium ground cover includes vines, medium level weeds, and miscellaneous plants. And high ground cover includes bushes, shrubs, and tall grasses. All open areas left on the layout where you still see plaster or terrain base, except for spaces reserved for buildings, will need to be covered with some kind of ground cover. Ground cover should also be added to some areas that are already colored, such as plants growing on rock faces, and vines growing on tunnel portals or retaining walls.

You have probably seen lawns that are perfectly trimmed and manicured with all the grass exactly the same color and cut to the same height. This is not typical on model railroads because it does not happen in nature or in the industrial areas that generally exist around railroads. The real world contains a variety of plants of different colors in varying heights, often growing wild in natural areas. People have a tremendous effect on these plants, not only by planting or removing them, but by their use of the areas where the plants grow. On the layout you will want to model this diversity in plants as well as landscape imperfections, both natural and man-made.

Woodland Scenics makes a number of products to help you easily and expertly add ground cover materials to the layout. First are the Earth Color Green Undercoat and Earth Undercoat Pigments. These Pigments are formulated as base colors to cover plasters as well as many other materials, including wood, foam and paper, which you may now have on the terrain base area of the layout. The next layer of material to be added is **Woodland Scenics Turf**, a ground foam material available in three grades, Fine, Coarse, and Extra Coarse. **Fine Turf** in two blended colors and all six individual colors will be discussed in the section on Low Ground Cover. **Coarse Turf** and **Extra Coarse Turf** will be discussed under the Medium Ground Cover section.

Your skills as a layout landscaper will increase with a little practice and also with having the proper tools and products to use. The Woodland Scenics Scenic Sifters provide the best method of storing and applying the Turf products. The easiest approach is to have one Scenic Sifter for each color and each grade of Turf. This allows you to select one at a glance without having to sort through bags of Turf or closed storage containers. Since Scenic Sifters are clear plastic, it will be obvious when one color of Turf is nearly gone. The colors are designed to blend with and complement each other, just like landscape colors in the real world.

LOW GROUND COVER

The best method of obtaining quick and complete coverage of the plaster and terrain base areas on the layout is to stain or paint them. Use Green Undercoat under primarily grass and foliage areas and Earth Undercoat

under rail yards and other non-foliage areas. By painting the terrain base areas first, you will be able to attach ground cover without worrying that the white plaster, Homasote, cellular Styrofoam, or cardboard will show through later on. Painting the Pigments on full strength or only slightly diluted will produce an opaque coat. Allow the Pigment to dry before adding further landscape materials.

The first layer of ground cover should be of the finest texture to represent earth, soil, grass, moss, and the smallest plants. The **Blended Turf** colors of Fine Turf are designed especially to color coordinate with Woodland Scenics Undercoat Pigments. Create a base coat of ground cover by selecting Blended Turf in Green Blend or Earth Blend appropriate for the type of area being modeled. Use the Scenic Sprayer and wet the area with Scenic Cement. If the first coat of Scenic Cement is applied to an absorbent surface, such as unpainted wood or plaster, it may absorb all the Scenic Cement and the Turf won't stick. Seal the surface first with Earth Color Liquid Pigment or a layer of Scenic Cement. The Scenic Cement will hold the ground cover materials in place and dry clear and colorless. Sprinkle on the base color of Blended Turf from the Scenic Sifter, trying for a uniform coverage. Allow the Scenic Cement to dry, and then vacuum up or blow off any excess Blended Turf. Turf can be used to cover up any surface texture by adding successive coats.

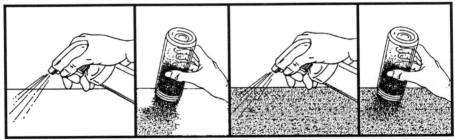

Attach Fine Turf by spraying the area with Scenic Cement from the Scenic Sprayer. Sprinkle on Green Blend or Earth Blend Turf from the Scenic Sifter for a base covering. After dry, vacuum or blow off the excess. Respray the area with Scenic Cement, then add additional colors of Fine Turf in both darker and lighter shades for color variation.

The Turf looks very monochromatic at this point. To get a more realistic look, add layers of more color and more texture to simulate the various sizes and colors of vegetation that really exist in the world. By continuing to use the Woodland Scenics system of products you will be able to achieve this realistic look just as easily as you added the first layer of color. Take a look now at Pages 70-73 for some color photos of sample landscape areas. These photos should provide some ideas on the type of look that can be created. It is all done with the Fine Turf products and the larger landscape items we will discuss in the next few sections.

BLENDING TURF

The key in adding additional color to the base layer of Blended Turf is to add other Fine Turf colors in a technique of blending. This involves creating areas of different colors, each blended into the underlying layer and into each other. Think of the Turf colors as a spectrum with a range from browns through yellows to greens. For the best effect in landscaping, begin in the middle of the spectrum with the Earth, Yellow Grass, and Burnt Grass as the first layers on top of the Blended Turf. Then add the colors on the outer edges of the spectrum, Soil, Green Grass, and Weeds, as accent colors. Try to achieve a *salt and pepper* or fine sprinkle technique to create

variations in color without harsh edges. With this technique you start by applying as little as possible, then repeat and overlap. Begin by misting the area of Blended Turf with Scenic Cement. Then, randomly add lighter or darker color on top of the Blended Turf by shaking a very light layer on in a salt and pepper fashion, blending it into the base coat and shading the edges into another color. Blow off any excess Turf, and spray a light mist of Scenic Cement to encapsulate it. Repeat with a different color. This process can be repeated as many times as desired. A final overspray of Scenic Cement will encapsulate the Turf making it more secure and easier to dust off later.

In some small areas there may be solid or semi-solid coverage with one color for accent. However, these are accent areas and not the general look desired for the entire layout. Shade the edges of various colors from one area into another. A darker green color could be used around lakes or streams where the ground is well watered and new vegetation is continually growing. Lighter green can occur in drier areas where vegetation does not receive much moisture. Sprinkle on some Yellow Grass or Burnt Grass to indicate dead grasses in the dry areas on mountain slopes or other rocky areas. Earth or Soil colors can be used to indicate bare spots of ground. Add the Fine Turf in thin layers for the most realistic appearance.

To make dirt roads, prepare the underlying area by painting with Earth Undercoat Pigment. Allow it to dry, then spray with Scenic Cement and add a layer of Earth or Soil color Turf in the proper width for your scale. Grasses and weeds would probably be growing along the sides of the road. Use small amounts of Fine Turf to model the lowest level of this vegetation. A path can

be added almost anywhere in a landscape area by forming it with a layer of Earth or Soil Turf in the appropriate width.

It is almost impossible to make Turf blending mistakes which are not correctable, so experiment with different colors, blending one into another salt and pepper style and shading from area to area. If you think you have put on too much of one color, just cover it up with another color. If a color appears wrong for a certain area, add another color on top. The materials are inexpensive and you will quickly learn how easy it is to create realistic low ground cover.

Very light salt and pepper sprinkles of Turf without a Scenic Cement base can be captured with an overspray of Scenic Cement. The final coat of Scenic Cement will be enough to hold it all in place, but be sure to mist very gently so the Turf material is not blown around by the force of the spray.

DRY BRUSH WITH TURF

An excellent technique for adding additional color to landscape areas with Fine Turf is the *dry brush* technique. This technique gives you the ability to add very controlled amounts of Turf very selectively. It also gives you the ability to see the result before fixing it in place.

Allow the Scenic Cement on landscape areas to dry completely before beginning. Use a dry paintbrush with soft fibers and paint on Turf just as you would paint. Dip the brush in the desired color of Turf. Brush the Turf on where desired to add color, highlight areas, and provide accents. If you don't like the result, blow it off or brush it off with a clean dry brush. When a desired result is achieved, mist lightly with Scenic Cement to fix.

This technique gives you more control over the placement of Turf than sprinkling Turf on with a Scenic Sifter. The dry brush technique can also be used to add Turf on top of Ballast or Talus to model the dirt which settles there.

MEDIUM GROUND COVER

Although there are now several different colors of Fine Turf on the layout, the look is still one of evenly mowed grass. In the real world, vegetation is not this uniform in size. The landscape rises and falls with plants of various levels growing in random patterns. This is what we call texture. To make the layout resemble the real world, color, size, and texture are needed in the landscaping.

The next stage in landscaping is to add a medium level of ground cover by creating different textures on the low ground cover area. Start this by using the six colors of Coarse Turf. The Coarse Turf represents the rougher weeds

and plants that grow almost everywhere, but particularly beside roads and railroad tracks, along streams, on mountains and hills, in mountain valleys, and around buildings.

Spray on a coating of Scenic Cement to help attach this material. Then use all of the different colors and apply in patches and groupings in the areas where these plants and weeds would grow. Blend the Coarse Turf colors with the underlying Fine Turf colors to create a unified look between the texture levels. Be sure to shade the areas of one color into areas of another color. An overspray of Scenic Cement should hold this material in place.

Another method of building up textured areas is to place mounds of Woodland Scenics Hob-e-Tac Adhesive or thick white glue on the layout and then oversprinkle with Coarse Turf. The glue itself creates the raised texture of the bush or weed and the Coarse Turf models the leaf structure on the top.

The Extra Coarse Turf represents the next texture level of weeds, coarse grass, and small plants. Extra Coarse Turf comes in six colors for blending with the other Turf sizes. Use a mix of colors because not all of these plants are exactly the same color. Mix this texture level into the areas previously landscaped, blending the colors with the layers already put down.

The Extra Coarse Turf pieces are large enough that they should be attached with Hob-e-Tac Adhesive or white glue. Apply spots and puddles of Hob-e-Tac Adhesive or white glue to the layout and then place the Extra Coarse Turf in the glue. After attaching them, go back and add some more Coarse Turf and Fine Turf around the edges to create an undulating look to the

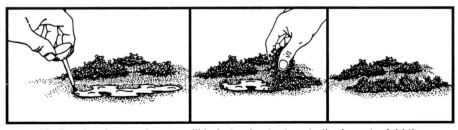

Medium level ground cover will help to give texture to the layout. Add the Coarse and Extra Coarse sizes of Turf in a variety of colors and attach with Hob-e-Tac Adhesive or white glue. This material will model undergrowth, low growing plants, weeds, and rough ground.

texture rather than individual items that stick up here and there. Extra Coarse Turf may be particularly useful as part of the camouflage around the edges of buildings and as ground cover in the larger scales.

Vines and other creeping ground covers are important parts of the landscape in virtually all parts of the country. Woodland Scenics offers two products to help you create these items. Foliage material and Poly Fiber will each give a distinctive look for different types of ground cover.

Woodland Scenics Foliage material comes packaged in a dense sheet. To use this material, tear off a section and then stretch and pull the material in all directions until it is thin and lacy. Save any material that falls off to use as low ground cover. Use the Foliage material to create vines and free standing ground covers which have a definite fiber or stem look, such as ivy or kudzu. Attach this material with white glue directly on the terrain base or to rock outcroppings, tunnel portals, retaining walls, bridges, building sides, telephone poles, and tree trunks. Vines can also be used to hide any faults or mistakes with buildings, seams in retaining walls, cracks, or gaps. As a final detailing feature, spray with Scenic Cement and sprinkle on some Fine Turf salt and pepper style to add variations in color. Or dry brush the high spots of Foliage with varying colors of Fine Turf and secure with Scenic Cement.

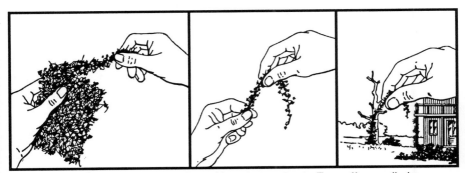

Foliage material comes packaged in a dense sheet. Tear off a small piece and stretch and tear it until thin and lacy. Use it for low ground cover or vines that have a definite fiber or stem. The material works well attached to tunnel portals, retaining walls, trees, bridges, buildings, or telephone poles. Foliage material is included in the Woodland Scenics metal tree kits.

Woodland Scenics Poly Fiber is a synthetic product that should be stretched until it reaches a very thin, transparent stage. Use Poly Fiber as a light delicate ground covering to model plants like crown vetch that have smaller stems and leaves and seem to almost float above the ground. Attach this material with small spots of white glue, then mist with Scenic Cement and salt and pepper sprinkle on Fine or Coarse Turf. This will add to the

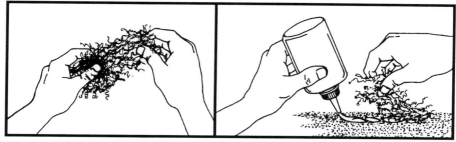

Poly Fiber is a synthetic material that can be used to model ivy, moss, and other ground cover plants. Stretch and pull the material to a thin lacy sheet. Attach to the layout with white glue which will dry clear.

appearance of leaves elevated above the ground by almost invisible plant structures. Model flowering plants by spraying the Poly Fiber with Scenic Cement, and carefully sprinkling pinches of Woodland Scenics Flowers on the top of the Poly Fiber.

HIGH GROUND COVER

The next step in creating realistic ground cover is to model the higher ground cover such as bushes, shrubs, and tall grasses. These types of plants grow in many areas in towns and across the countryside. Bushes appear as random clumps along rights of way, on the sides of hills, and in open country. They appear along fence lines, around buildings, and near water areas. Tall grasses and weeds are found in many areas beside tracks, along rivers and streams, at the edges of lakes and ponds, in open areas, beside junk piles, in rocky terrain, and around buildings.

Woodland Scenics Foliage Clusters and **Woodland Scenics Clump-Foliage** are patented products made with ground foam. They are not organic and will

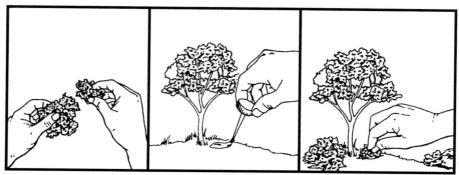

Foliage Clusters can be broken into smaller pieces for bushes and shrubs, or used as foliage for trees. Clump-Foliage is already ground to the most useful sizes. Attach with Hob-e-Tac Adhesive or white glue. These materials can also help camouflage the bases of buildings and other problem areas.

not dry out or crumble. Foliage Clusters come in large pieces which can be used as is or broken into smaller pieces in any size you need. They are available in three colors. Clump-Foliage is already broken into the smaller sizes most useful for bushes and ground cover. It is available in six colors including a Fall Mix. Use Hob-e-Tac Adhesive or white glue to attach to the layout.

Tear off small pieces from the large clusters and plant in the areas where bushes or shrubs might grow. Or use Clump-Foliage as is. Tear off very small pieces and use Hob-e-Tac Adhesive to glue them to the ground in clumps. Keep the bushes in clumps, planted in random patterns around the layout. Be sure to consider scale when planting bushes. Although real bushes and shrubs grow in a variety of sizes, most of them are no taller than an adult. Use a mixture of colors and sizes for the most realistic look.

Glue Clump-Foliage and Foliage Clusters to the layout then use the smaller Turf sizes to blend the edges into the rest of the landscape. Clump-Foliage and Foliage Clusters can be used to cover mountains and to partly obscure some rock outcroppings. They can also be useful for hiding the line where the benchwork joins the wall behind or to help hide the edges of a lift-out section where a tunnel occurs.

TECH TIP

Several detailing touches can be added with the Turf and Foliage products. Use Clump-Foliage or Foliage Clusters to make a hedge. Plant by a house or building with Hob-e-Tac Adhesive or white glue.

Use an eyedropper or fine brush to spread a little Scenic Cement in the cracks in sidewalks and streets. Sprinkle on a little Fine Turf to model the grasses which would be growing there.

Earth colored Coarse Turf can be used as the ground cover in stockyards and loading pens. Add some Earth or Soil colored Fine Turf on top of Talus or Ballast to model the dirt which would naturally collect there.

Woodland Scenics *Lichen* is an organic material. Because of this fact, lichen will dry out and, if extremely dry, might crumble when being handled. Woodland Scenics Lichen may dry out when humidity is very low but it is treated to stay soft under normal humidity conditions. It can be resoftened by spraying it with a fine mist of water. However, if you live in a very dry area, you might want to consider using Clump-Foliage or Foliage Clusters rather than Lichen on your layout.

Before using Lichen, break up the large pieces into a variety of sizes. To give Lichen a more realistic look, mist the top with Scenic Cement and sprinkle on Fine or Coarse Turf. This gives the Lichen the appearance of a bushy structure with leaves on top. After sprinkling on the Fine or Coarse Turf,

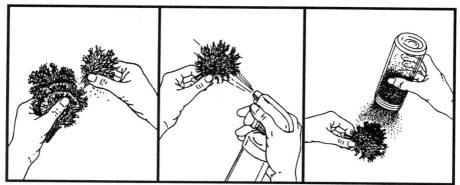

Use clumps of Lichen as bushes or to fill background areas with trees. Pull off a clump of Lichen in an appropriate size. Spray with Scenic Cement and sprinkle on some Fine or Coarse Turf to add detail and additional color. Lichen can be attached to the layout with white glue.

attach the Lichen to the layout with white glue. Adding Fine or Coarse Turf to the Lichen makes it look more realistic and similar to the other landscape materials. This means that Lichen and other landscape material can be mixed on the layout and still maintain a uniform realistic look.

Clump-Foliage, Foliage Clusters, or Lichen can be used successfully to hide junctions between buildings and the layout. Whether the buildings are attached directly, simply set in place, or installed on pieces of plywood, their junction with the layout should be camouflaged with landscape materials for a more natural look. Use the Clump-Foliage as is or break up the Foliage Clusters or Lichen into various sized pieces and attach with Hob-e-Tac Adhesive or white glue over the joints. Use the smaller Turf sizes to blend the larger bushes together.

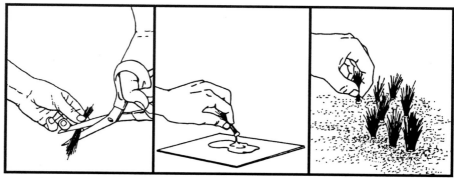

Roll a small clump of Field Grass between your thumb and index finger to produce uneven lengths. Then cut the other end of the clump evenly with scissors to an appropriate length for your scale. Place a small amount of Hob-e-Tac Adhesive on a sheet of paper. Dip the blunt end of the Field Grass in the Hob-e-Tac and plant on the layout.

Woodland Scenics Field Grass comes in several colors to represent both living and dormant grasses. For the most realistic look, use a variety on the layout. Since grasses and tall weeds usually grow in clumps, total coverage of an area is not needed for a realistic look. Plant scattered clumps in likely areas, and blend the colors with the other ground cover for realism.

To create an uneven look to the top of the grass, roll some fibers around between your thumb and index finger in an uneven circular pattern until the ends have various heights. Pinch these fibers between the other thumb and index finger and trim off evenly in an appropriate length for your scale. Place a small amount of Hob-e-Tac Adhesive on a sheet of paper. Dip the blunt end of the Field Grass into the Hob-e-Tac and plant on the layout. For grass that is somewhat matted down, spread the top fibers a little before the Hob-e-Tac sets. Plant as many clumps of grass as needed to obtain the look you want. Add a little Fine Turf around the base of the field grass to cover the Hob-e-Tac and represent even shorter weeds, grass or earth. Another technique is to touch the tops of the Field Grass with the flat side of a small paintbrush dipped in white glue. Sprinkle on some Fine Turf and let it

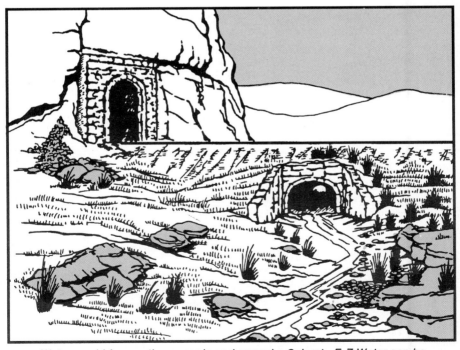

Water would frequently appear in and around a Culvert. E-Z Water can be added at the bottom of the Culvert in a well-defined stream or as pools of remaining water in a nearly dry Culvert. Surface rock might be seen in the area near a Culvert.

adhere to the white glue. This is particularly good for representing plants like cattails and milkweed.

For a whole field of Field Grass clumps, paint a few square inches at a time with Hob-e-Tac Adhesive. Take a small bunch of Field Grass between thumb and index finger and poke the blunt end onto the Hob-e-Tac. Trim off at the proper height, poke again, and trim, etc. Plant as many bunches of grass as desired for the area.

If the layout includes farm fields, first color the area with Earth Undercoat Liquid Pigment. When dry, spray with Scenic Cement and sprinkle on Soil or Earth colored Fine Turf. Small clumps of Clump-Foliage, Foliage Clusters, or the larger Turf sizes can be placed in rows to indicate crops or gardens. Small clumps of Field Grass can also be placed in a row. A fast way to plant a row of Field Grass is to use a large clip designed for potato chip bags to pick up tufts of Field Grass and place in an even row on Hob-e-Tac Adhesive.

After installing the Clump-Foliage, Foliage Clusters, Lichen, and Field Grass, stand back and look at all the landscape materials added to the layout. If there are any harsh colors or unnatural splotches of color, now is the time to add some Fine Turf to alter the color a little and blend it into the rest of the colors. Spray with Scenic Cement and add whatever colors are needed salt and pepper style on top of what is already in place. The dry brushing with Turf technique is ideal to use. Dip a dry paintbrush in whatever color Turf you want to add, paint it on where you want it, and then overspray with Scenic Cement.

TREES

Only in very select areas of the country are there no trees growing. So, unless you plan to model the extreme desert areas, trees will be needed on the layout. Trees add color, texture, geographic orientation, and realism to your layout. They are also important for providing view blocks that allow the trains to briefly disappear and reappear again.

Trees are not just trees! Different varieties of trees have different shapes and color, different types of foliage, and varying heights. Even within a tree species there are differences, depending on the age of the tree and the growing conditions of its environment. How specific you plan to get with the trees on the layout depends on your interests and imagination.

Trees generally fall into two categories, conifers, which retain their needles year round, and deciduous, most of which lose their leaves in fall or winter. Your layout could include trees of only one of these kinds or a mixture of the two. The selection of trees on your layout will help set the tone for the geographic location of the railroad.

TREE SHAPES

This chart shows some of the various tree shapes and foliage patterns seen in real world trees. Create individual species of trees with as much or as little foliage as desired.

Woodland Scenics products provide a variety of methods for creating good looking trees that are easy enough for the beginner yet will be realistic enough for the craftsman. Let's look at some of the areas where you might want to put trees and the products that can help.

When planting trees, keep in mind that trees generally occur in groups rather than individually. Look around to see the kinds of places where trees grow. Trees require sunlight and water to live. Therefore trees are found in open areas, on the sides of hills and mountains, around streams and other bodies of water, near houses, and as fence rows. Be sure to leave sufficient clearance for the trains if trees are planted near railroad tracks.

Woodland Scenics Ready Made Realistic Trees are the fastest and easiest method of getting highly detailed good looking trees onto the layout. They come in a large variety of deciduous shapes and sizes, in either green or fall foliage. Ready Made Realistic Trees are also available in several sizes of conifers. Just use these trees as they come and plant them on the layout. If you prefer slightly less foliage or wish to shape a particular variety of tree, pluck off any excess foliage material before planting. Save this excess foliage to use as bushes or ground cover. The trunks of these trees are made

from a bendable plastic which does not have a memory, that is, they can be bent and reformed as often as needed. The armatures (branch structure) can be shaped to match the look of a particular species of tree or to fit into a particular area on the layout. The trunks are precolored in a flat gray brown color with a bark texture. However, they can be further detailed if desired by additional coloring with the Earth Color Liquid Pigments.

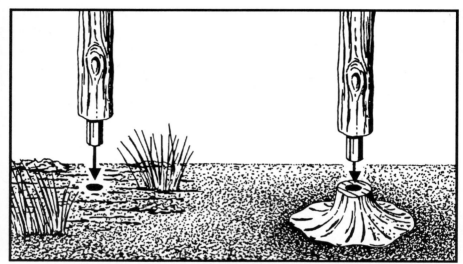

Woodland Scenics trees are planted by placing the base pin into a hole drilled in the terrain shell. For temporary placement, place the base pin into the optional base. When the permanent location is decided, discard the base and plant the base pin directly into the terrain shell.

Ready Made Realistic Trees are hand crafted to provide you with the ultimate in natural color and realistic detail. Use a mixture of tree sizes on the layout, no matter what scale is being modeled, because trees in the real world exist in different sizes. Also, be sure to use various shades of green to represent the differences in the colors of real trees.

Woodland Scenics Ready Made Realistic Trees are easily planted on the layout. Check the instructions for the size needed, then drill the proper size hole in the layout base and push the base pin on the tree into it. Use some Hob-e-Tac Adhesive to attach the tree. Temporarily placing the base pin in the plastic base that is provided with the tree will allow you to move the trees around a little to see how they will look. When a permanent location has been determined for the tree, install it by drilling a hole for the base pin and discarding the temporary base. Glue the tree in place with Hob-e-Tac Adhesive and place some extra Turf or Foliage material around the base of the tree to represent fallen leaves or small weeds and bushes.

Woodland Scenics Realistic Tree Kits are very economical. Depending on the size used, the trees can be built for as little as 30¢ per tree. The Realistic Tree Kits include the same trees as the Ready Made Realistic Trees, only in a form that you put together yourself. Both deciduous and conifer trees are available in a number of sizes and come with precolored Clump-Foliage material that is attached with Hob-e-Tac Adhesive. The Realistic Tree Kits are easy enough for a beginner to assemble because of their two-step construction.

Realistic Tree Kits contain bendable plastic trunk armatures with bark texture that are already precolored a flat gray brown color. The armature is packaged flat, so first of all, bend and twist it to an appropriate shape. The trunks are bendable at room temperature, can be repositioned, and will hold the new shape. More detail can be added to create bark highlights if desired. Holding the tree armature upside down, spray or brush on Scenic Cement and allow it to dry. Using this technique prevents any puddling of Scenic Cement in the Vs of the branches where it will be noticeable. Daub or spray on diluted Slate Gray, Stone Gray, or Concrete from the Earth Color Liquid Pigments. Allow this to dry and spray or daub on a Black wash. This technique allows for color matching the bark on a particular variety of tree.

Assemble Realistic Tree Kits by twisting and bending the plastic trunk armature to the desired three dimensional shape. Add extra color or detail to the trunks with Earth Color Liquid Pigments. Clump-Foliage can be broken up into smaller pieces if needed for your scale or tree variety. Glue on the Clump-Foliage with Hob-e-Tac Adhesive.

After completing any detailing of the trunks, attach the Clump-Foliage with Hob-e-Tac Adhesive. The clumps may be used as they come or broken into smaller clumps. By doing the assembly yourself, you create exactly the look you want with as little or as much foliage as you feel necessary. The trees are planted by drilling a small hole in the terrain shell or terrain base, inserting the base pin and securing with Hob-e-Tac Adhesive. Use the temporary base if you want to move trees around the layout while deciding on their permanent locations.

Woodland Scenics Tree Kits with metal trunks are designed to include more detail. They take more time to build and have a more lacy see through

look. The kits contain white metal trunk armatures with more character and detail than the plastic armatures of the Realistic Tree Kits. The densely packaged Foliage material in these kits is designed to provide an open lacy look to the tree foliage.

To assemble trees from the metal trunk Tree Kits, first twist and bend the armature to a three dimensional shape you like. Color the metal armature with the Earth Color Liquid Pigments using the same technique as noted above with Realistic Tree Kits. Stretch and tear the Foliage material in all directions until thin and lacy. Save any material that falls off and use it as ground cover or bushes. Gather a clump of the Foliage material and glue onto the tree armature with white glue. Each tree you create can be unique because you bend and paint the armatures, and you add the Foliage material.

1. Tree Kits with metal trunks are constructed by first bending the flat armatures into a three-dimensional shape. Color the armatures with the Earth Color Liquid Pigments for a realistic look. 2. Stretch and tear the Foliage material in all directions until thin and lacy. 3. Gather a clump and attach it to the armature with white glue.

After working with the metal armatures, be sure to wash your hands thoroughly and do not place the armatures in your mouth.

Woodland Scenics Pine Forest Kit and **Hardwood Forest Kit** are inexpensive "bulk pack" tree kits. The Pine and Hardwood Forest Kits each contain 24 trees with metal trunks of varying heights. The Pine Forest Kit includes Coarse Turf which is attached to the armatures for foliage. The Hardwood Forest Kit contains a sheet of branch material which must be spray painted, stretched until thin and lacy, and attached to the armature. The included Coarse Turf must be added to complete the tree. Hardwood Forest trees are particularly good for modeling the smaller sapling type of trees which can be mixed in with larger trees. The **Woodland Scenics Hedge Row Scene**

contains not only 18 trees but also bushes, branch material for foliage, brown undergrowth material, and Turf material. It is the economical way to build a complete hedge row 24" to 30" long, designed just as you want it to fit the layout area.

If you prefer, you can custom make trees using a variety of materials for the trunk armatures. Successful tree armatures have been created using several varieties of weeds and plants selected for their ability to appear in scale in the small sizes. Twisted wire can also be used to model tree armatures. Use Woodland Scenics Clump-Foliage, Foliage material, Foliage Clusters, or Poly Fiber to complete the foliage on these trees. Highlights and detailing can be added by misting these foliage materials with Scenic Cement and adding a light sprinkling of Fine or Coarse Turf.

More detailing touches can be added to enhance the realism of your trees. Try lightly spraying the foliage with Scenic Cement and lightly sprinkling a lighter Turf color on top of the tree and a darker color on the bottom. This gives the tree the look of sunlight hitting the top and shadows at the bottom. Fruit or flowers can also be added by spraying the foliage lightly with Scenic Cement and carefully sprinkling on the **Woodland Scenics Fruit** or **Flowers** products to form fruit or flowering trees.

Keep in mind that trees generally occur in groups rather than individually. Also remember that different varieties of trees have different shapes. Woodland Scenics Realistic Trees and Tree Kits give you the opportunity to shape and alter the trees as needed to create the look of a particular species. Even if the forest is made up of trees of the same variety, some will have lighter and some darker foliage. Using some of all the kinds of Woodland Scenics trees will give your layout the most realistic look because it duplicates the variety actually found in nature.

TECH TIP

Create deciduous trees which are partially fall colored and partially green to model the transition between summer and autumn. Spray the Fall Mix Ready Made Realistic Trees with Scenic Cement. Sprinkle on small amounts of green Fine Turf to create varying amounts of green and fall color in the tree.

If the layout is being done in fall colors, use the Ready Made Realistic Trees which come in a fall mix of colors. Be sure to mix trees of various colors when planting. Or use the Realistic Tree Kits and substitute the two selections of fall colored Foliage material, the fall mix Clump-Foliage, or the autumn mix Lichen for the Clump-Foliage in the kits. Then use the green Clump-Foliage in other areas for bushes or shrubs.

To save money and time you may want to fill in a background area with trees that are not as detailed. These trees are the ones that are either far enough away from the viewer or clumped so closely together that no individual trees can be distinguished. They form a tree mass. A tree mass can be used to hide the junction of the layout base with the wall behind, or to foliate an entire mountain slope. We suggest that you use Clump-Foliage, Foliage Clusters, or Lichen thickly clumped and attached directly to the layout with Hob-e-Tac Adhesive or Flex Paste to create a tree mass.

With the tree mass technique of making trees you do not have to worry about tree trunks because they will not be seen anyway. Remember to use a mixture of realistic colors because a forest is not all the same color. Spray the tops of the Foliage Clusters or Lichen lightly with Scenic Cement and sprinkle on a lighter color of Fine or Coarse Turf. This will vary the color and give the impression of sunlight on the mountain or forest. This step is particularly important with Lichen to give it the realistic look of foliage.

Height differences can be created by using toothpicks as trunks for some of the Clump-Foliage, Foliage Clusters, or Lichen in the tree mass. The rest of the foliage will hide the toothpicks so they will not be seen, but they will create the illusion of some taller trees. Attach the Clump-Foliage, Foliage Clusters, or Lichen to the toothpicks with Hob-e-Tac Adhesive or Flex Paste and plant them by drilling a small hole in the terrain base. A bit more Hob-e-Tac Adhesive or Flex Paste will keep the toothpick in place. Use detailed trees with trunk armatures on the front edge

TECH TIP

To model a logging scene or build huge conifer trees, modify the Realistic Tree Kits. Use a saw to cut a tapered piece of balsa, basswood, or cedar in the height desired. Depending on the scale, the trees could be up to three feet tall. Use a rasp to further taper the wood to a thinly pointed shaft with a rough bark texture. Stain the wood with grays and browns from the Earth Color Liquid Pigments.

The plastic trunk armatures from the Realistic Tree Kit are each used as separate branches. Leave the armature relatively flat and glue on tufts of the Conifer Green Clump-Foliage. Drill holes in the wood trunk and insert the branches, large armatures at the bottom, graduating up to the smallest armatures at the top. Attach with Hob-e-Tac Adhesive or white glue. Add some Fine Turf to the north side of the tree to simulate moss.

of the tree mass to create the illusion that all the trees in the mass have trunks.

To give the layout forest area a final realistic look, add some dead or dying trees, some fallen branches, and some stumps. Use either the plastic or metal type of armatures with little or no foliage for dead and dying trees. Or, purchase the Woodland Scenics Dead Trees Kit. Fallen branches can be made by cutting or breaking up some of the armatures and placing them on the forest floor. Be sure to add some Foliage material to represent the weeds and mosses that would grow up around a fallen tree branch. Realistic stumps can be purchased as **Woodland Scenics Stumps.** Stumps are particularly important in a logging scene but can appear anywhere, such as along the edge of a field or fence row.

Use several tree-making methods on the layout. Highly detailed trees should be at the front of the layout, closest to viewers. The inexpensive way to fill large background areas with trees is to use Clump-Foliage, Lichen, or Foliage Clusters without any trunks. For a few background trees which are taller, use toothpicks as trunks and plant in holes drilled into the terrain shell.

WATER

Because water areas are so common in the form of rivers, streams, lakes, ponds, harbors, and puddles, they should be included on the layout. But water has typically been something of a problem on models due to the difficulty in finding a material to use that will look natural. Real water has been used on models but it does not appear to be in scale, it gets stagnant and evaporates, and is difficult to keep confined where you want it. Glass, mirrors, Plexiglas, and other materials have all been used to model water. Two part mixable plastics are frequently used to create water. They are sometimes difficult to mix in the proper proportions and once set are not alterable.

We recommend **Woodland Scenics E-Z Water** for modeling water areas. It is a low odor, nontoxic plastic product that comes in the form of pellets which are melted and poured into the prepared area on the layout. It is particularly appropriate for water areas where you want to model flowing water such as creeks, streams, or rivers. E-Z Water is easy to use because there is no measuring, no mixing, and it sets rapidly. Texturing of the water surface and repairs such as scratches can easily be accomplished after E-Z Water is in place with the use of a heat gun.

Locating areas for water on the layout can be considered when the original contours are created. During the newspaper wad contouring stage, leave flat level areas where lakes, ponds, or harbors will be located. Rivers and streams will flow in the valleys between the hills and mountains. These impressions will be created naturally as you build the terrain. To add water areas after the initial contouring is done, cut into the contouring material with a hobby knife and repair the cuts with Plaster Cloth. Or, use Lightweight Hydrocal to build up areas around a pond or create river banks. Be sure to allow all contouring materials located under the areas where E-Z Water will be poured to dry thoroughly before adding E-Z Water to the layout.

Preparing E-Z Water Areas: It is probably easier to wait until the complete ground cover landscaping is in place before adding E-Z Water to the layout. In most situations, it will be adequate to pour E-Z Water only approximately 1/8" deep. Look at the areas where you plan to pour the E-Z Water. The contour materials around the edges of the areas where you plan lakes, harbors, or ponds may already be sufficient to hold 1/8" of liquid. If not, use some Lightweight Hydrocal or strips of Plaster Cloth to build up the banks. Be sure the bottom of these areas is level. To contain rivers and streams in specific areas, you may need to build up the banks a little with Mold-A-Scene or Plaster Cloth. E-Z Water will be heated to a high temperature before pouring. Therefore, do not pour it directly onto cellular Styrofoam or any other material which will melt.

Before pouring E-Z Water, the area underneath must be sealed to help prevent air bubbles from rising into the water. To do this, paint on a thick layer of Flex Paste wherever you plan to pour the E-Z Water and let it dry. Be sure to seal all cracks and holes. E-Z Water will set quickly enough that a small hole will not allow it to leak out. However, small cracks or holes will permit air bubbles to rise into the E-Z Water.

Coloring E-Z Water Areas: Flex Paste remains white when it is dry. E-Z Water is transparent and nearly colorless. Therefore, color must be added for a realistic looking result. Preparing water areas which have color can be done by coloring the bottom of the area or by a combination of coloring the bottom and tinting the E-Z Water itself. The water you get from the kitchen tap is clear and generally colorless, but water in its natural setting is seldom this pure. The water in lakes, ponds, rivers, and oceans has dirt, algae, and other organisms in it that help to color it. Water also reflects color from the sky and foliage surrounding the body of water. You probably remember seeing water that looked blue, green, brown, black, gray, milky, tan, and mixtures of these colors. Creating these kinds of colors in your water areas is done before pouring the E-Z Water.

For a greenish brown coloring of water areas, use Stone Gray Liquid Pigment brushed on full strength over the Flex Paste for an opaque covering. Allow the pigment to dry. Spray with Scenic Cement and sprinkle on a thin but even coating of Fine Turf premixed in the following proportions: two parts Earth, two parts Burnt Grass, and one part Soil. Allow to dry completely before pouring E-Z Water.

Other combinations of Earth Color Liquid Pigments and Fine Turf colors can be used to create water areas with different coloring. Experiment to find the combinations that you like best. If you want to indicate more depth, add a darker color of Turf under some areas. Use Soil or Earth Fine Turf for this purpose. Blend the colors from the more shallow areas into the deeper areas for the most realistic look.

Deeper water areas like large lakes, ports, and oceans are the most likely to appear somewhat blue green. Brush on an opaque layer of a medium to dark blue green acrylic paint to achieve this color. Avoid the lighter and brighter blues because they do not look natural. A little black color may be added to some areas to indicate the deeper water.

If you want to tint the E-Z Water itself, this can be done with an appropriate color of powdered Rit dye. Do not add any liquids to E-Z Water as they could boil over and cause burns. We suggest Navy Blue, Dark Green, or Pearl Gray Rit Dye. Add 1/16 tsp. of powdered Rit dye to one bag of E-Z Water pellets before melting. Be sure to thoroughly mix the dye with the E-Z Water as it melts using a disposable wooden stick. When the E-Z Water reaches a liquid

stage, place a couple of drops on aluminum foil to check the color. If it is too light, add more powdered Rit dye. If it is too dark, add a little more E-Z Water. Prepare the water area in the same manner as above with a coating of Flex Paste. Then cover with Liquid Pigment and a sprinkling of Fine Turf before pouring the E-Z Water.

Ballast, Talus, Turf material, or tree limbs from the Realistic Tree Kits can be attached to the bottom of the water areas before pouring E-Z Water. Attach these items with super glue after the Flex Paste covering is on and the area has been colored. Allow everything to dry thoroughly. If you want sediment to float in your E-Z Water, sprinkle some Fine or Coarse Turf in the water area, but do not attach it. When the E-Z Water is poured, this material will be suspended in the E-Z Water. Items such as sticks, rocks, or weeds may contain moisture or air pockets that will cause bubbles to form in the E-Z Water and are therefore not particularly desirable. Any plastic items you plan to imbed in E-Z Water, such as boats or people, should be tested first with a small sample of liquid E-Z Water. These plastic items may be melted by the E-Z Water.

Pouring E-Z Water: Melt the E-Z Water pellets in a clean, dry disposable tin can because the residue is difficult to remove. A Teflon coated pan can also be used. E-Z Water can be removed from the Teflon, but may stick to the outside of the pan. Caution: E-Z Water is very difficult to remove if

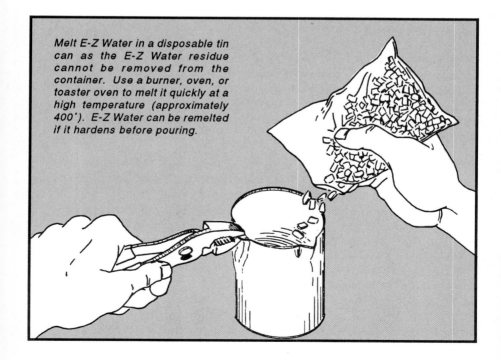

Melt E-Z Water in a disposable tin can as the E-Z Water residue cannot be removed from the container. Use a burner, oven, or toaster oven to melt it quickly at a high temperature (approximately 400˚). E-Z Water can be remelted if it hardens before pouring.

spilled on a burner or in an oven. Use an appropriately sized container for the amount of pellets being melted to keep the liquid in a mass rather than thinly spread out.

Melt E-Z Water quickly at a high temperature on a burner, or in an oven or toaster oven set at 400°. Smoking indicates the E-Z Water is too hot. Although not dangerous, the temperature should be reduced. You may want to use a disposable non-melting utensil such as a tongue depressor, craft stick, dowel rod, or old spoon (not plastic) to gently stir the E-Z Water. This

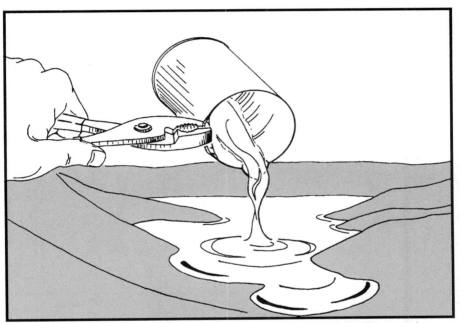

Pour E-Z Water into the prepared area as soon as it is liquid. It will set nearly colorless and transparent. E-Z Water can be reheated if it hardens before pouring. Prolonged exposure of melted E-Z Water to high heat will cause it to darken slightly.

will help distribute the heat and promote quicker melting. Alternative heat sources such as a candle, heat lamp, Sterno stove, or propane stove will also work. Do not add any liquids to E-Z Water. They will not mix with the plastic and could erupt in a dangerous manner. Caution: the heated material is hot enough to severely burn your skin.

As soon as the pellets are liquid, pour into the prepared area on the layout. If the E-Z Water hardens before pouring, just remelt. The pellets are nearly colorless when melted but they will darken slightly if continuously exposed to heat in a melted form for more than 15 minutes. E-Z Water will harden

in just a few minutes, depending on how deep it is poured. One package of E-Z Water will cover approximately a 14" diameter circle when poured 1/8" deep.

Repairing E-Z Water: Use a heat gun to remove air bubbles or make any repairs which are needed. Heat guns are available at hardware or home building stores and are labeled as heat guns. Home hair dryers do not produce sufficient heat to melt E-Z Water. A heat gun may be used before the E-Z Water has set or after it is completely set. Hold the heat gun approximately six inches from the surface of the E-Z Water and move it continuously in a circular pattern as you remelt the surface. This allows the air bubbles to escape. Scratches and cracks are repaired by remelting the

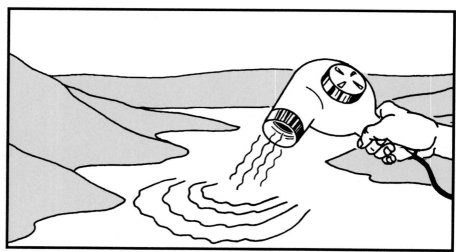

Use a heat gun to add ripples or other texture to the surface of hardened E-Z Water, and to remove air bubbles. Aim the hot air at the surface of the E-Z Water until the surface begins to melt and the desired result is achieved.

surface with the heat gun which allows the scratches to disappear and the edges of the cracks to merge together. A rounded lip may occur along the edges of your body of water where the E-Z Water cooled too quickly. Use the heat gun to blow hot air along the rounded lip and flatten it out.

Talus, Ballast, Turf and Coarse Turf can be used along the edges of streams and other bodies of water. Glue them down after the E-Z Water has hardened. Because Talus is somewhat porous, some bubbles may appear when using it in conjunction with E-Z Water. These can be removed with a heat gun after the E-Z Water has hardened.

Texturing E-Z Water: Texturing of the E-Z Water is done with a heat gun. Pour the E-Z Water and let it harden. Ripples can be produced by blowing

hot air across the surface of the body of water to slightly melt the E-Z Water. The force of the moving air will form a ripple effect in the surface of the E-Z Water. Other textures can be added by carving on the surface of the hardened E-Z Water with a hobby knife or compass and then softening the surface slightly by blowing hot air from a heat gun. The carvings will soften slightly and reharden, looking like a natural part of the water. In this way, circles can be created to indicate where a fish jumped or a rock was thrown

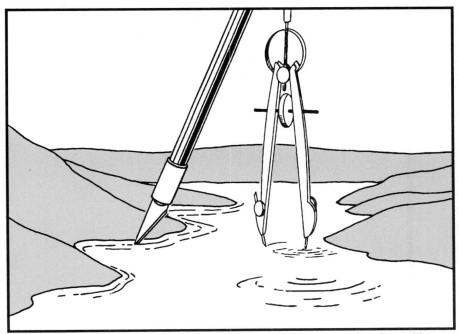

Textures can be added to E-Z Water by marking the hardened surface with a hobby knife or compass and then heating with a heat gun until the surface softens. If the marks completely disappear, allow the E-Z Water to harden, then begin the process again.

in the water. Should any scratches occur on the bodies of water, they can be repaired by remelting the E-Z Water in place with a heat gun. Be sure to keep the heat gun moving in a circular or conical pattern as you use it on the E-Z Water to prevent getting too much heat in one spot. If Field Grass has been installed in or near the E-Z Water, be careful not to singe it with the heat gun.

An alternate method of using E-Z Water that is particularly good for filling in streams or for putting water into hard to reach areas is to place the E-Z Water pellets directly on the prepared layout areas. Then, use a heat gun to melt them in place. Hold the heat gun about 24" from the pellets to begin, then move it in slowly as the pellets begin to melt. With this method you will

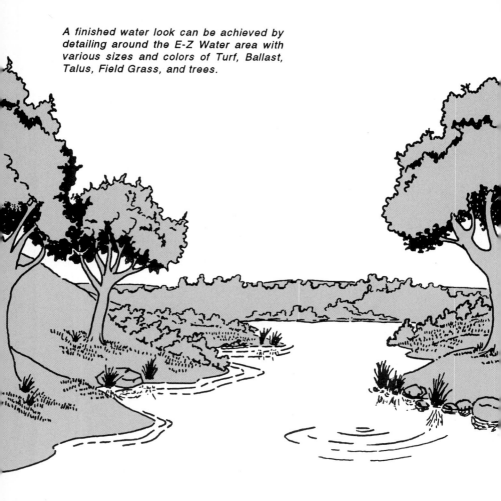

A finished water look can be achieved by detailing around the E-Z Water area with various sizes and colors of Turf, Ballast, Talus, Field Grass, and trees.

be able to get water into hard to reach areas like culverts, under rock overhangs, or alongside track in a tunnel.

DETAILING LANDSCAPE

Because of the variety that can be achieved in landscaping a layout, it can be one of the most interesting and exciting parts of building a railroad. As you have progressed through the various parts of this chapter, your skills in observing real landscape items should have increased. The end result is that even after "completing" the landscape portion of the layout, you will notice additional ways to use the products. Feel free to back up and add additional landscape items, or find new ways to use the products. This is known as detailing the landscape, that is, adding more detail after the initial landscaping is in place.

Since few, if any, model railroads have too much landscape material, check to see if a little more color, a little more texture, or a little more variety in landscape materials is needed. Additional Turf, Talus, Foliage material, and trees can easily be added on top of what is already in place. The more texture on the layout, the more interesting and the more realistic it will appear. If the landscape seems to be too even in texture, add some more Coarse and Extra Coarse Turf or put in some more bushes with Clump-Foliage, Foliage Clusters, or Lichen. Maybe some more vines and trailing plants are needed. Use some Foliage material or Poly Fiber and look for more areas where these items might grow. Add some Flowers in selected spots, perhaps around a stream or in an open field where wild flowers would grow. Be sure to plant clumps of Field Grass beside track, near water areas, and in open areas. Any additions made to the landscape at this point should enhance the realism of the scene and provide a better backdrop for your trains.

TECH TIP

Even with a completed layout, rock outcroppings, field rocks, and boulders can be added. Cast these rocks with Lightweight Hydrocal and color with the Earth Color Liquid Pigments to match existing rock. Then add them to the layout attaching with Lightweight Hydrocal to a plaster surface, and Flex Paste or white glue to any other surface. Add some landscape materials to blend the new rocks into the rest of the scenery.

Maybe your layout has been around a few years and the landscape materials are starting to look shabby. Renew the whole look of the layout with a fresh application of Turf, some additional Clump-Foliage or Foliage Cluster bushes, a few new trees, and perhaps a water area that did not exist before.

Look critically at all areas of the layout for places where some detail items would really make the scenery look more realistic. Take a look at the rock outcropping areas you have created. In the real world, vegetation seeks every possible place to put down roots. Mist the rock faces with Scenic Cement or hair spray and add small amounts of Turf or small pieces of Foliage Clusters on ledges and in crevices. The dirt and grime which appears on rocks can be modeled with Fine Turf in Soil color in a flyspeck technique. Lightly mist the rock face with water. Place a small amount of Soil colored Fine Turf on a sheet of paper which has been bent into an L-shape. Hold the paper near the rock face and lightly blow air onto the paper to puff flyspecks of Soil onto the rock faces. When you achieve the look you want, lightly mist with Scenic Cement to hold in place.

No matter how severe the terrain, there are almost always trees trying to find a way to grow out of rock faces. Trees with thin armatures from the

Hardwood Forest Kit or Pine Forest Kit are appropriate for modeling saplings trying to get a start. Drill a nearly horizontal hole in the rock outcropping. Then bend the bottom of the tree armature in an L-shape to model a tree growing out of the rock.

Field Grass is another item that can be used to provide very realistic vegetation for rock areas. Small tufts of grasses can be added on a rock ledge and around the edges of a rock outcropping. Almost any surface rock, boulder, or field rock would have clumps of Field Grass growing around it. Around the bottom of tunnel portals or retaining walls is another likely location for clumps of Field Grass.

Field Grass is also useful in detailing other areas of the layout. It can give a feeling of abandonment or neglect to sections of the railroad. Field Grass would almost surely be growing between the rails and around the track area of an abandoned siding. It would be seen in industrial and mining areas where the grounds are not landscaped or tended. Virtually any fence would have some tufts of Field Grass around it, as would the supporting poles for a billboard or sign posts.

These detailing items are not difficult to add to the layout. What is mostly required is good observation of the real world and practice in using the Woodland Scenics products to produce the desired effects.

THE SCENERY KIT

Many of the products and techniques presented here and in Chapter II can be learned using The Scenery Kit by Woodland Scenics. Even if you do not yet have a layout, you can perfect your skills as a terrain and landscape modeler by building The Scenery Kit. It is a display piece you will be proud of and it allows you to show off an engine or piece of rolling stock while continuing to build a layout. See Page 132 for a photo and complete description of contents.

CHAPTER SUMMARY

BALLAST THE TRACK

Provide extra stability for ties and rail as well as a realistic look by installing Woodland Scenics Ballast on all track areas. Pour Ballast down the middle of the track and spread with a dry paintbrush. To attach the Ballast, mist lightly with Woodland Scenics Scenic Cement, then thoroughly soak the Ballast with Scenic Cement. Or, mix the Ballast with Dry Ballast Cement before spreading, then spray with wet water to attach. Be sure to clean off the rail when the glue is dry. To review this section, see Page 76.

ADD TALUS (ROCK DEBRIS)

Woodland Scenics Talus (rock debris) should be added in all areas around rock outcroppings and mountains as well as in and around water areas. Talus is also seen on top of and around the bottom of tunnel portals and retaining walls. Place the smaller sizes of Talus first with the larger sizes on top. Add another layer of Fine Talus. Spray with wet water and attach with a white glue and water mixture dropped on top of the Talus. To review this section, see Page 79.

BUILD ROADS

Build roads to connect towns, provide access to businesses and industries, and allow people to get to their homes. If a road area has not been formed during initial contouring, use cardboard strips or Mold-A-Scene Plaster to provide a flat surface. Cover with strips of Woodland Scenics Plaster Cloth or apply Woodland Scenics Lightweight Hydrocal and sand if needed for smoothness. In the larger scales, apply Ballast to make a gravel road. In the smaller scales, make a gravel road by painting with Earth Color Liquid Pigment Concrete and lightly sprinkling some Earth Fine Turf into the wet Pigment. Paint with Earth Color Liquid Pigment Concrete or Slate Gray to make concrete or asphalt roadways. Add detailing in the form of ruts, cracks, or tire tracks. To review this section, see Page 80.

CREATE LOW GROUND COVER

Paint or stain all remaining open areas with Woodland Scenics Undercoat Pigments in Green Undercoat or Earth Undercoat. Sprinkle a uniform coat of Woodland Scenics Blended Turf on these painted areas using Scenic Cement as an adhesive. Use the six colors of Woodland Scenics Turf (Fine) to add additional color and detail to these areas. Create darker and lighter highlights which are blended into the base coat of Blended Turf. For realism, blend color with salt and pepper, dry brush, and flyspecking

techniques. Create dirt roads and paths by surfacing those road areas with Earth or Soil colored Fine Turf. To review this section, see Page 82.

MEDIUM GROUND COVER

Texture in the form of plants of different heights should be added with Woodland Scenics Coarse Turf and Extra Coarse Turf, using several varieties of colors. Blend these products into the previous layers of Fine Turf and Blended Turf. Model ivy, vines, and other medium level plants with Woodland Scenics Poly Fiber and Foliage material. Pull and stretch these products to a thin sheet or strip and attach to the layout with white glue. To review this section, see Page 85.

HIGH GROUND COVER

Continue adding more texture with Woodland Scenics Clump-Foliage, Foliage Clusters, and Lichen used as bushes and shrubs. Pull off pieces of different sizes and plant them in clumps and groupings around the layout. Detail these bushes with dustings of Fine Turf for variety in color and texture. Add random clumps of Woodland Scenics Field Grass in both wet and dry areas to model tall grasses and weeds. To review this section, see Page 88.

PLANT TREES

Finish the ground cover by planting trees. Use Woodland Scenics Ready Made Realistic Trees for quick easy trees which are highly detailed and realistic. Woodland Scenics Realistic Tree Kits and metal trunk Tree Kits allow you to shape the armatures and foliate the trees to your own liking. Plant any of these trees by drilling a small hole in the layout base and inserting the pin on the tree trunk. Attach with Hob-e-Tac Adhesive or white glue. To review this section, see Page 92.

POUR BODIES OF WATER

Seal the areas which will be the bottoms of lakes, ponds, streams, and harbors with a thick coat of Woodland Scenics Flex Paste. Paint the Flex Paste to give color to the water. Use Earth Color Liquid Pigments or acrylic paints to achieve a realistic color. Add landscape materials to model the plant growth on the bottom of ponds and lakes. Melt the Woodland Scenics E-Z Water pellets in a disposable tin can and pour into the prepared areas. Remove air bubbles and add detailing with a heat gun. Melt E-Z Water Pellets directly on the layout with a heat gun to form a creek. To review this section, see Page 100.

Chapter IV

STRUCTURES AND DETAILING

With the benchwork, track, terrain, and landscaping done, you nearly have a completed layout. However, there are a few more items needed to add the final touches and produce a finished product that you can be proud of. Structures, detailing, and dry transfers are these final additions to the railroad. They are important because they make the whole scene seem to come alive.

You have probably been thinking about structures all along and perhaps have some locations created for them. Maybe you have a few structures built. Now is the time to get them placed on the layout and add all the finishing touches that enhance their realism.

Another area we will look at in this chapter is detailing. When model railroaders talk about detailing their layouts or models, they mean adding all the items that individualize and enhance the reality of the scene. Detailing can take your railroad and models out of the ordinary category and push them toward excellence. Even if the layout is pretty well completed, many detailing touches can still be added to make the models and layout unique.

Signs can be seen as part of detailing, but they will be discussed as a separate topic because of their importance in adding color, interest, and realism to the

layout. They are an easy item to add to either a new layout or a more completed one.

STRUCTURES

A railroad layout with completed terrain and landscaping is ready for the buildings that will fill in the spaces left for towns, industries, rail facilities and yards. Structures are important on the railroad to give it a time orientation and help set a geographic location. They can also help camouflage structural problems and provide view blocks for the trains.

Hobby shops carry a wide variety of building kits for structures in paper, wood, plastic, cast resin, and metal, as well as ready made buildings. The skill range needed for these kits runs from those which require a very minimum of construction to those which are literally a box of sticks and require *craftsman* level skills to construct. Another option for building structures is to purchase or fabricate the pieces yourself and *scratchbuild* whatever buildings you desire. If you are a beginning modeler, stick with the easier kits at first, until you get some experience and practice in building. These buildings can always be replaced later on with scratchbuilt or craftsman type structures as your skills increase.

The structures placed on the layout can be those associated with the railroad itself such as roundhouses, coaling facilities, depots, or ice facilities; industrial buildings like mines, sawmills, stamp mills, or logging facilities; and city or town buildings such as houses, stores, service stations, and local businesses. Plan to include a mixture of these types of structures on the layout for the most realism. Do not think just in terms of large buildings. Many of the buildings that occur frequently on the railroad landscape are small ones—tool sheds, outhouses, storage sheds, and line shacks. These small structures can add a lot of character and realism to the layout without a lot of time or cost in building.

As you select structures to buy or scratchbuild, be sure to note the size and shape that the base of the structure will require. This information may be included in the kit or in the plan for a scratchbuilt structure. Make a paper pattern in the size and shape of the base of each building you plan to include. These can be moved around the layout to select locations for structures and to make sure they will fit. This is particularly important if you are working with a small layout area.

Some of the best quality building kits available at a reasonable price are those made by Design Preservation Models. They have an extensive line of highly detailed injection molded styrene building kits. There is also the freedom to design your own buildings with their modular building sides. These can be put together in various ways to make a custom structure to fit

your layout. The kits include both city and industrial structures. With the modular pieces, it is possible to design almost any type of building. The Design Preservation kits are economical as well as easy to build. Lots of additional detailing can be added to make totally unique structures which will make any modeler look like an expert.

Woodland Scenics Complete Scene Kits and **Trackside Scenes** are designed for the modeler who wants fine quality craftsmanship, intricate detail, and authenticity. The same detail and craftsmanship can be found in the many small buildings available in the **Woodland Scenics Scenic Details**. Complete

Scenic Details are buildings, vehicles, or other small items cast in white metal with lots of intricate detail which is cast into the parts. They are easy to assemble by cleaning the castings with a file and gluing together with super glue. Paint with the Woodland Scenics Mini-Scene Paint Set.

Scenes are ones that could be used almost anywhere on the layout, but may be particularly appropriate in a town area. Trackside Scenes are specific industries and scenes that would be seen along the track area. The Scenic Details buildings include a variety of town and rural structures.

Each of the Complete Scenes and Trackside Scenes contain white metal castings, plus all the Turf, trees, and accessories needed to finish the scene. The Scenic Details buildings include the structure plus figures or detailing items needed to complete it. Use the **Woodland Scenics Mini-Scene Paint Set** to complete any of these kits. Individual instructions are included with each kit. In general, the metal pieces are filed to smooth rough edges, trial

fitted, and assembled with super glue. The Mini-Scene Paint Set includes 12 colors for painting any of the scene kits. Be sure to wash your hands after working with the kit pieces and do not put any of the pieces in your mouth.

How structures are attached to the layout varies, depending on what the structure is and where it is to be placed. If the structure is fairly stable and is going into a flat space, you may not wish to attach it at all. Just set the structure in place and then use some of the Turf products, Clump-Foliage, Foliage Clusters, Field Grass, or Poly Fiber to plant bushes and grass around the bottom of the building to conceal its connection with the layout. This also works well if a building is going to be moved to a different location later on or replaced with another building.

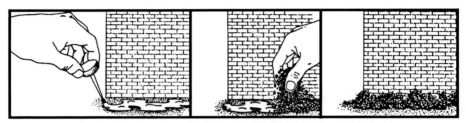

Camouflaging the junction of buildings with the layout and hiding seams or cracks in terrain areas will give a more realistic look to the layout. Spread Hob-e-Tac Adhesive or white glue to cover these seams and cracks and then add the Turf products, Foliage material, Clump-Foliage, Foliage Clusters, or Lichen to create the appearance of bushes, vines and weeds.

More permanent placement can be done by attaching the building to a piece of plywood, Masonite, or plastic. Then landscape the piece, and place the whole piece on the layout. Use the landscape products to conceal the edges of the piece of wood and blend into the other scenery. Some buildings may look better if their bases are slightly recessed into the terrain base of the layout. Using a very thin piece of Masonite may avoid this situation. However, if it cannot be avoided, cut a shallow recess in the Plaster Cloth, or other table top material, the size of the base of the building or the piece of wood it is attached to. Set the building in this recession. More Plaster Cloth or Mold-A-Scene can be used around the edges to smooth out the terrain, and Turf products can be used to blend the building into the landscape.

Because of the way they are constructed, some buildings may need to be attached directly to the layout. This is particularly true in the case of structures sitting on uneven terrain or those that fit into the sides of mountains, such as mines. Use Flex Paste, Lightweight Hydrocal, Hob-e-Tac, super glue, or white glue, depending on the material of the structure and the layout material it is being attached to. See Page 125 for another method of attaching structures. It involves making a Plaster Cloth mask of the area

where you want the building, moving the mask to your workbench, attaching the building to the mask and then installing the whole piece on the layout.

Keep in mind that once attached, the structures cannot be easily moved around to another location or removed to a new layout. If a building is fairly inexpensive and easy to construct, this may not be a problem. But if it is a craftsman kit or scratchbuilt structure with many hours of labor involved, other alternatives might need to be considered before permanently attaching

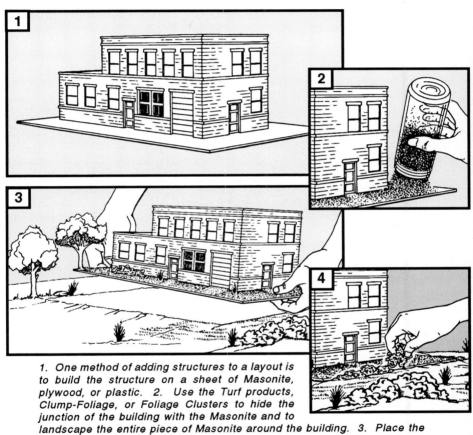

1. One method of adding structures to a layout is to build the structure on a sheet of Masonite, plywood, or plastic. 2. Use the Turf products, Clump-Foliage, or Foliage Clusters to hide the junction of the building with the Masonite and to landscape the entire piece of Masonite around the building. 3. Place the Masonite and structure in place on the layout. 4. Then use Clump-Foliage, Foliage Clusters, Turf, Field Grass, or Foliage material to camouflage the junction of the Masonite with the rest of the layout.

the structure to the layout. Perhaps the structure can be built as part of a small diorama which is attached to the layout. Then this entire diorama might be able to be moved to another location or layout. Another possibility is to build the structure as part of a small modular section of the layout. This module, with the structure attached, could then be moved to a new location.

DETAILS

Now is the time to look critically at the layout to see what areas need some additional detailing. There are probably areas that can use some extra landscape materials to provide more ground cover or more variety of color or texture. Some extra rock outcroppings or field stones might make the scene look more natural. Perhaps there are some areas where structural problems such as the junction of the terrain base and side or back contour boards can be better camouflaged by more bushes or a grouping of trees. Be sure talus of various sizes has been placed around tunnel portals, retaining walls, along the bottom of culverts, down mountain valleys, and below rock cliffs.

What about the buildings? Have you put in driveways, sidewalks, parking lots, and paths as demanded by the type of building? Remember that the world is not always neat and clean. Add some oil spills around railroad facilities and service stations, and some spilled rock and coal around mines or loading areas. Put some ruts in roads or cracks in concrete items. Stretch Foliage material or Poly Fiber to make vines, ivy, moss, or other clinging plants on buildings, tunnel portals, and retaining walls.

Woodland Scenics Mini-Scenes and **Scenic Details** provide many possibilities for small scenes and detail items. All are highly detailed and realistic to add interest to the scenery. Each Mini-Scene includes everything needed to build and landscape a small scene that can be incorporated into the layout to add interesting or amusing detail. Included in the Scenic Details are a number of items that can be added along track areas, in towns, and rural areas. These include such items as water towers, fuel stands, street and traffic lights, skids, mailboxes, and vending machines. These small detailing items can often make the difference between a good layout and a great layout.

Color is another important detailing item. Be sure to look carefully at the layout for places where color can be added. The actual landscape colors which appear in the world are fairly muted, but this does not mean that splashes of color do not exist. If the general appearance of the layout is dull, look for spots to add color. Remember that rock areas contain more than one color. Perhaps you need to go back and add more color to these castings. Look at the ground cover and foliage to make sure there are some lighter and some darker areas. Patches of flowers or some flowering or fruit trees can also help add color. Have you fully detailed the buildings and towns with the addition of signs, posters, and advertisements? Colorful vehicles, people, animals, street signs, and street markings can be spread around the layout to add both color and interest. The Scenic Details include a number of vehicles and animals that are very helpful for this type of detailing. Also a number of the Mini-Scenes and Scenic Details include figures of people.

Many industries, mines, businesses and homes have various types of junk lying around—discarded machinery, barrels, pallets, lumber, rocks, tree branches, lengths of pipe, tires, and chunks of concrete. Industrial Junk, Trackside Junk, or Assorted Junk Piles are available from Woodland Scenics as part of the Scenic Details line. These pieces are ready to paint and place on the layout. Or use leftover pieces from kits, broken items, excess chunks of castings, small lengths of scale lumber, and other small items you might be considering throwing away. Mix them all together to place behind buildings, in yards, or near mine entrances. Mix in some landscape material and plant some Field Grass growing out of the pile to create a very realistic junk pile.

SIGNS AND GRAPHICS

Look around at buildings, signs, train cars and engines on the layout. One thing that is immediately noticeable is that they almost always have some kind of writing, numbers, or pictures on them. The layout will appear bland and unrealistic if this facet of the real world is not duplicated.

Woodland Scenics Dry Transfers and **Model Graphics Dry Transfers** are a very effective method of detailing engines, rolling stock, buildings, fences, vehicles, and other items. They are easy to use on either smooth or textured surfaces, leaving no unnatural film around the edges. Dry Transfers will adhere to wood, metal, paint, plastic, paper, and other surfaces. Numbers and letters in a variety of typefaces and colors are available, as well as stripes in various widths and colors in Model Graphics Dry Transfers. Woodland Scenics Dry Transfers include some letters and numbers as well as railroad heralds, boxcar data and labeling, warning signs, business signs, advertising signs, posters, and company logos. It is even possible to create individualized signs by using the letters, numbers, and stripes.

Dry Transfers are very easy to use, even for beginners. Just position the Dry Transfer where you want it, rub gently on the top with a burnisher, and slowly lift off the carrier sheet. Then place the backing paper over the decal and gently rub again. To attach to a textured surface, burnish carefully. Then press the Dry Transfer into the ridges or bumps

TECH TIP

Be sure to include Dry Transfers as a detailing feature on windows. Advertising signs would appear on the windows of stores, taverns, restaurants, and depots. Dry Transfers can easily be added to these areas without leaving an unsightly film around the edge of the sign. The Mini-Series Dry Transfers include signs which are small enough for windows in N scale.

with your thumb or a gummy type eraser, and it will stretch and adhere in cracks and crevices as fine as brick texture.

Numbers, letters, stripes, boxcar data, and warning signs can be used on engines and rolling stock to create extra detail, add color, and personalize them for your railroad. Use the advertising signs and logos on buildings, vehicles, signs, billboards, and fences. Some of the signs indicate a particular time period that can help with the time orientation of the layout.

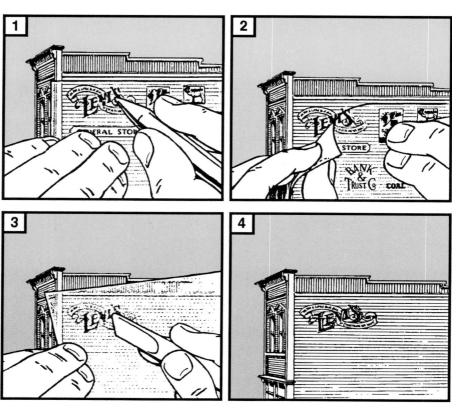

Woodland Scenics Dry Transfers can be attached to any surface, smooth or textured. Position the Dry Transfer where desired and rub over it with a burnisher or dull pencil. Carefully pull away the carrier sheet. Then place the backing paper over the decal and burnish again. Use a gummy type eraser or your finger to work the Dry Transfer gently into a textured surface.

Chapter V

DIVIDE AND CONQUER

FOR NEW MODELERS

A lot of information has been discussed in the last four chapters, and it may seem like too big a project to start. The purpose of this chapter is to help you break the whole project down into smaller parts which can be accomplished more easily. We call this divide and conquer, that is, divide the whole project into smaller parts and conquering or completing one part before going on to the rest.

Although the techniques discussed in this book are easy enough for beginners to use, there is no doubt that a little practice will improve the final product. One of the best ways to get this practice is with **The Scenery Kit** by Woodland Scenics. This kit allows anybody, with or without a layout space, to get started now in learning the terrain and landscape techniques. With The Scenery Kit you can build an 10" X 18" diorama which can be used to display an engine or piece of rolling stock. The kit contains the materials and supplies needed for the complete project.

Specifically, The Scenery Kit includes complete instructions plus the pre-cut hardboard sides, Plaster Cloth, Lightweight Hydrocal, rock castings, Culvert, track, Ballast, Talus, six colors of Turf, two colors of Clump-Foliage, Field Grass, Poly Fiber, four colors of Earth Color Liquid Pigments, Trees, Hob-e-Tac Adhesive, and Scenic Cement needed to complete the diorama. The complete instructions take you step by step through the process and show you exactly how to use each product which is included in

the kit. You can build The Scenery Kit yourself or the kits could become the base for a clinic at a model railroad meet or work session for a railroad club. The result is a diorama you will be proud to display with an engine or piece of rolling stock.

Just as importantly, you will use and practice the skills needed to create terrain and landscaping on other projects. This small project gives you some practice in the various techniques and some familiarity with the products available. With this background experience, a larger project will seem more manageable.

The next step might be building a small diorama which can become part of the larger railroad layout later on. Consider using one of the Woodland Scenics Complete Scenes, Trackside Scenes, or Mini-Scenes for this project. These kits are convenient because they include everything needed for a complete scene, except glue and paint. If you already have a structure to build a diorama around, the **Woodland Scenics Complete Landscape Kit** should provide enough Turf products and trees to finish the scene.

Another method of starting small is to build a module, either as a member of a modular group, or as a piece that will later be incorporated into the larger layout. In fact, an entire layout can be done in modular sections that are connected together as they are built to create a whole railroad. The Complete Landscape Kit will be helpful here too as it contains a variety of materials to get started on the landscape section of the module.

If you are standing in a basement, garage, or railroad room wondering how to fill it with a layout, don't panic! Start with just one section, perhaps a corner or other small identifiable area. Begin there with benchwork, track, wiring, terrain, and landscape. Complete this section before moving on to an adjoining section and eventually the railroad will be built around the room. By breaking the whole project down into manageable units, you not only get something that is possible to accomplish, but it is a lot more fun.

Maybe there is no space available right now for a railroad. This is another situation where you may choose to begin by building The Scenery Kit or some of the Complete Scenes, Trackside Scenes, or Mini-Scenes. You will be able to work on improving your skills and then when you have room for a railroad you will already have a number of dioramas that can be built into the layout.

FOR EXPERIENCED MODELERS

For an experienced modeler there is always something new to do in model railroading. A railroad is an ongoing project and maybe you will want to remove a section of track, terrain, and scenery on the layout and build it again. Or go back and add some features that were left out the first time—tunnels and retaining walls, rock outcroppings, or water areas. Perhaps you

would like to experiment with doing a section of the layout in fall colors. It is also possible to build a couple of interchangeable sections depicting different seasons.

If you have a complete layout constructed, you may want to use it for operating sessions and do some new construction on a different project. What about joining a module group and building a module? Consider building in a different scale or gauge, or creating an entirely different type of scenery. Or, your community may have a railroad club that needs volunteers to help build their layout.

Perhaps you want to get involved with a different facet of model railroading. There are several possibilities here. One that may interest you is model photography. The photos can be entered in special photo contests at railroad meets or used for your own purposes. You can photograph scenes already on the layout or build specific dioramas just for photography purposes. Photography can involve some different types of modeling techniques including the temporary building of dioramas where the landscape materials are not attached to the diorama.

If you have an interest in writing, there are a number of model railroading magazines that are always looking for articles on layout construction, landscape techniques, detailing, and other facets of the hobby. Purchase a few copies of these magazines and study the type of articles that they use.

A SECTIONAL MODELING TECHNIQUE

After a layout has been completed, there may be some changes or additions you want to make to it without doing major construction. Perhaps you just want to add a building or some rock outcroppings to an existing layout. Maybe you are trying to add something in an area that is difficult to access, change the contouring of an area, or create an access panel. There is an easy method to solving these problems.

First, remove any trees or large bushes in the area that is to be changed. Cover the area with aluminum foil, fitting it tightly to the contours which exist. Next, cover the foil with strips of Plaster Cloth shingled 50% on the previous sheet and 50% on new territory and allow it to dry. For more strength, add either another layer of Plaster Cloth or apply a layer of Lightweight Hydrocal on the Plaster Cloth. What you are actually making is a cast or mask of the specific terrain area.

If you want to add a rock outcropping or change the contouring, remove the whole foil and Plaster Cloth section to the workbench. Add the rock outcropping in the method described in Chapter II, color it, and allow it to dry. If changes in contouring are desired, add newspaper wads and cover with Plaster Cloth strips to make the new shape desired. Peel off the

Adding a rock outcropping or building to a completed layout can be done easily at the workbench. 1. This illustration shows the layout area where the addition is to be made. 2. Remove any existing trees and bushes if there are any from the area where the rock outcropping or building is to be added. Fit aluminum foil tightly to the terrain and cover with Plaster Cloth shingled 50% on the previous sheet and 50% on new territory. This creates a removable mask. 3. When the Plaster Cloth mask has dried, remove it to the workbench to add the rock outcropping or building. 4. The newly completed section is then attached to the existing layout with a perfect fit.

aluminum foil and attach the whole piece to the layout. It should fit
perfectly. Use Lightweight Hydrocal, Flex Paste, or white glue as an
adhesive. If using Lightweight Hydrocal, be sure to spray or paint water on
both surfaces before applying the Lightweight Hydrocal. Blend the
landscaping on the new piece into the original layout. Replant the bushes
and trees, and the new terrain addition is finished.

Adding a building is another simple project. Begin by fitting the foil to the layout area and covering it with Plaster Cloth. Before removing this mask, add a small platform in the size of the building base. Use plywood or Masonite for the actual platform and some wads of newspaper underneath to hold it up and make it level. Masking tape will hold the wads in place, just as it did with the original contouring. Cover the platform and newspaper wads with Plaster Cloth and allow to dry. Now remove the whole piece to the workbench. Finish the structure and attach it to the platform. Add some rock outcroppings under the platform to give the structure the look of being built on a rock ledge. Remember to add some kind of road going to the structure for access. When the piece is completed, remove the foil and attach the whole thing with an exact fit to the layout. Use any landscape items needed to blend this new section into the previous layout area.

Creating an access panel where one has not existed before can easily be done with this technique. First mark the area on the layout which you plan to remove for the access panel. Before removing it, fit aluminum foil to an area covering the intended access panel plus an inch or so extra on all sides. Cover the foil with Plaster Cloth and allow to dry. Move this mask to the workbench and add whatever rock outcroppings or landscape materials are desired. Using a jigsaw, cut out the access panel from the layout and discard. The newly created access panel cover can now be set in place. Do not glue it in place, it will be supported by the extra inch of Plaster Cloth you added on all sides. Use some Clump-Foliage, Foliage Clusters, or Lichen to hide the edges of the panel but do not attach them. Whenever needed, the Foliage Clusters can be moved, the panel raised for access, and everything returned to its original place.

This technique can also be used for adding buildings to an uneven surface. See Page 116. Use it to see how a rock outcropping or building will look in a particular area of the layout before installation. And it allows you to make a mask of a hard-to-reach area, then move to the workbench where you easily and more comfortably add rock outcroppings and buildings.

SOME FINAL THOUGHTS

Model railroading is a hobby for life because you can bring many levels of interest, experience, and expertise to this one hobby. Begin with a module or small layout with some fairly basic techniques and buildings. Then add on or create a whole new and perhaps larger layout once you have gained more experience. The key is experimenting with new products and new ideas.

Many people say that a model railroad is never finished. This is true in the sense that you can always add to or improve the engines, rolling stock, and structures. It is also true that you can continue to add scenery items and

details. Likewise, you can remove parts of the scenery and begin again if you do not like a particular terrain area or want to put in a different section of track. Woodland Scenics products assure you of a continuation in high quality products, color matches in products, and product availability.

Remember that people are a big part of model railroading too. Check around your local area to find out if there are any model railroad clubs or special interest groups. Get to know some of the people and attend some shows, swap meets, or a convention. Or join the National Model Railroad Association and through it find out about local activities. You will get a chance to learn some new things and share your ideas with other people who have the same interests. Model railroading is a hobby with many facets. Get involved as much or as little as you like in whatever areas interest you. Have fun!

CONCLUSION

We trust this book has given you the information you need about techniques and products to help you add scenery to your model railroad, diorama, military model, dollhouse scene, or school project. We believe your models will look better with realistic scenery and that you will be pleased with your efforts and success.

The most important message we hope to have conveyed is that creating scenery is not beyond the scope of any modeler, even beginners. Remember that the systems and products in this book make it almost impossible to make mistakes that are not correctable.

Now all you need is the enthusiasm and inspiration to get started. Rather than planning to start "some day", why not do it now? Even starting a small project will give you valuable practice and experience. It's up to you now. So have a good time with your modeling project.

We welcome your comments and suggestions about current Woodland Scenics products and any ideas you may have for products you would like to see produced. Drop us a note at: Woodland Scenics Scenery Manual, P.O. Box 98, Linn Creek, MO 65052. Or visit us at our clinics and booth at the annual conventions of the National Model Railroad Association. There you will be able to talk with company representatives and preview the newest Woodland Scenics products and techniques.

PRODUCT LISTING

Woodland Scenics products provide complete systems for terrain building, landscaping, and detailing your models. All of the products are easy to use and are designed to color coordinate and complement each other for the greatest possible realism. These products represent the most advanced level in the evolution of scenery-making products and techniques.

The following pages provide a partial product listing with color samples at the back. If you would like a complete catalog of all Woodland Scenics products, send five first class postage stamps or $1.50 to: Woodland Scenics, P.O. Box 98, Linn Creek, MO 65052.

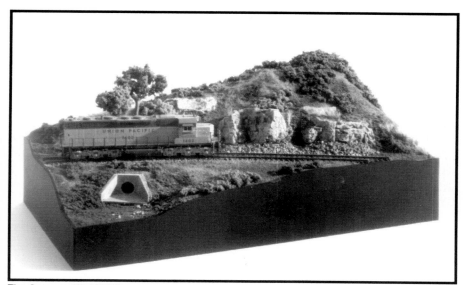

The Scenery Kit (S927)

The Scenery Kit offers you the opportunity to learn the terrain and landscape building techniques needed for completing the scenery on a larger module or layout. In just a couple of evenings you will gain a wide range of skills that can be put to use improving your layout. Included are complete instructions and hardboard sides plus the Plaster Cloth, Lightweight Hydrocal, Culvert, rock castings, Earth Color Liquid Pigments, Ballast, Turf, Clump-Foliage, Poly Fiber, Talus, and Trees needed to complete this 10" X 18" display piece. Use it to show off an engine or piece of rolling stock.

Medium Green Foliage (F52)

TURF, COARSE TURF, EXTRA COARSE TURF, BLENDED TURF

Turf, Coarse Turf, and Extra Coarse Turf are made of ground foam material with six colors in each grade for all your landscape needs. Blended Turf comes in two fine blends for use as a base coat on landscape areas. These products give you the most realistic colors and textures allowing you to mix and blend for maximum realism.

FOLIAGE CLUSTERS*

A specially produced ground foam product ideal for creating bushes, undergrowth, and tree foliage. Available in three realistic colors.

LICHEN

A natural product which can be combined with the Turf and Foliage items to model bushes, ground cover, and foliage. Lichen is available in a variety of colors for modeling any season of the year.

Medium Green Foliage Clusters (FC58)

SCENIC CEMENT

This ready to use matte-medium formula can be sprayed or brushed on and dries to a clear matte finish. It is a nontoxic water base cement which can be used in innumerable ways on the layout. Available in an economical 16-oz. bottle.

SCENIC SIFTER

The clear plastic Scenic Sifter comes with two interchangeable, snap-on sifter caps in different sizes making it easy to apply Ballast, Turf, Coarse Turf, and Extra Coarse Turf to the layout. Blank labels and a solid lid for storage make this the ideal way to store all the Turf and Ballast products for easy identification and availability.

SCENIC SPRAYER

Durable 8-oz. plastic bottle with a long siphon tube and spray head with nozzle that adjusts from very fine mist to a steady stream. Use for spraying water, wet water, salt water, Scenic Cement, and Earth Colors. Spray head also fits Scenic Cement bottle.

***WOODLAND SCENICS PATENTED PRODUCT**

Light Green Mix Lichen (L167)

Scenic Cement (S191), Scenic Sifter (S193), Scenic Sprayer (S192)

133

FIELD GRASS

A natural hair product in four colors perfect for modeling tall grasses and weeds. Four colors are available for modeling both green and golden grasses.

POLY FIBER

This synthetic fiber can be stretched and torn to form airy, almost transparent types of ground cover. Use it for ivy, vines, and delicate plants.

TREE KITS*

The metal trunk tree kits are designed to include more detail, to take more time to build, and to have a more lacy see through look. Bend the armatures to your specifications, color them, and add the Foliage material to model particular varieties of trees or create a tree to fit a particular area.

BALLAST

Realistically model ballast on the railroad with a choice of seven colors and three sizes to fit almost any area of the country and any scale. Also use Ballast to model gravel roads, rock piles, and hopper loads.

HOB-E-TAC ADHESIVE

A multi-purpose high tack adhesive which bonds on contact. Particularly good for attaching Field Grass to the layout and making and installing trees.

Hob-e-Tac (S195) Field Grass (See page 146)

Five Pine Trees TK23

Poly Fiber (FP178)

*WOODLAND SCENICS PATENTED PRODUCT

Light Gray Ballast (B74)

REALISTIC TREES SELECTION GUIDE

ITEM NUMBER	ACTUAL HEIGHT	COLOR	TREES PER PKG	SCALE HEIGHT N 1/160	SCALE HEIGHT HO 1/87	SCALE HEIGHT O 1/48
GREEN DECIDUOUS						
TR1001	3/4"-11/4"	MED GREEN	8	10' - 17'	5' - 9'	3' - 5'
TR1002	11/4"-2"	MED GREEN	5	17' - 27'	9' - 15'	5' - 8'
TR1003	2" - 3"	LT GREEN	4	27' - 40'	15' - 22'	8' - 12'
TR1004	2" - 3"	MED GREEN	4	27' - 40'	15' - 22'	8' - 12'
TR1005	2" - 3"	DK GREEN	4	27' - 40'	15' - 22'	8' - 12'
TR1006	3" - 4"	LT GREEN	3	40' - 53'	22' - 29'	12' - 16'
TR1007	3" - 4"	MED GREEN	3	40' - 53'	22' - 29'	12' - 16'
TR1008	3" - 4"	DK GREEN	3	40' - 53'	22' - 29'	12' - 16'
TR1009	4" - 5"	LT GREEN	3	53' - 67'	29' - 36'	16' - 20'
TR1010	4" - 5"	MED GREEN	3	53' - 67'	29' - 36'	16' - 20'
TR1011	4" - 5"	DK GREEN	3	53' - 67'	29' - 36'	16' - 20'
TR1012	5" - 6"	LT GREEN	2		36' - 44'	20' - 24'
TR1013	5" - 6"	MED GREEN	2		36' - 44'	20' - 24'
TR1014	5" - 6"	DK GREEN	2		36' - 44'	20' - 24'
TR1015	6" - 7"	LT GREEN	2		44' - 51'	24' - 28'
TR1016	6" - 7"	MED GREEN	2		44' - 51'	24' - 28'
TR1017	6" - 7"	DK GREEN	2		44' - 51'	24' - 28'
TR1018	7" - 8"	MED GREEN	2		51' - 58'	28' - 32'
TR1019	8" - 9"	MED GREEN	2		58' - 65'	32' - 36'
FALL DECIDUOUS						
TR1040	11/4"-3"	FALL MIX	9		9' - 22'	5' - 12'
TR1041	3" - 5"	FALL MIX	6		22' - 36'	12' - 20'
CONIFERS						
TR1060	21/2"-4"	CON GREEN	5		18' - 29'	10' - 16'
TR1061	4" - 6"	CON GREEN	4		29' - 44'	16' - 24'
TR1062	6" - 7"	CON GREEN	3		44' - 51'	24' - 28'
TR1063	7" - 8"	CON GREEN	3		51' - 58'	28' - 32'

REALISTIC TREE KIT SELECTION GUIDE

ITEM	ACTUAL HEIGHT	COLOR	TREES PER PKG	SCALE HEIGHT N 1/160	SCALE HEIGHT HO 1/87	SCALE HEIGHT O 1/48
TREES						
TR1101	3/4" - 3"	LT, MED,	36	10' - 40'	5' - 22'	3' - 12'
TR1102	3" - 5"	DARK	14	40' - 67'	22' - 36'	12' - 20'
TR1103	5" - 7"	GREEN	7	67' - 93'	36' - 51'	20' - 28'
PINES						
TR1104	21/2" - 4"	CONIFER	42	33' - 53'	18' - 29'	10' - 16'
TR1105	4" - 6"	GREEN	24	53' - 80'	29' - 44'	16' - 24'
TR1106	6" - 8"		16	80' - 106'	44' - 58'	24' - 32'

READY MADE REALISTIC TREES*

The quickest and easiest way to add well-detailed realistic trees to your layout is with Woodland Scenics Ready Made Realistic Trees. There are 25 different packages of trees to give you all the variety you need in three shades of green deciduous trees, dark green conifer trees, and fall color deciduous trees. Each package contains between two and nine trees depending on size. Each tree is hand crafted so each is unique. If you want to model a particular variety of tree and want a little less foliage, just pluck a little off.

REALISTIC TREE KITS*

The Realistic Tree Kits give you the same type of tree as Ready Made Realistic Trees, only in kit form. It's the way to quickly, easily, and economically fill your layout with trees. Realistic Tree Kits come in six different varieties of both deciduous and conifer trees in a selection of sizes. You will be able to create up to 42 trees per kit depending on size. The plastic trunk comes packaged flat so you can bend and shape it to whatever form you want. If you wish you can even add extra detailing to simulate a particular type of tree. Then attach the Clump-Foliage to create exactly the shape of tree you want with the amount of foliage you prefer.

CLUMP-FOLIAGE (PATENT PENDING)

A ground foam product produced in the ideal size to create bushes, ground cover, and foliage for trees. Available in six realistic colors including a fall mix.

Realistic Tree Kit, 36 Trees 3/4"-3"(TR1101)

TUNNEL LINER FORM

Each pour of Lightweight Hydrocal in this mold creates half of a single or double track tunnel with realistic rock walls and ceilings.

EARTH COLOR KIT

The economical way to use the Earth Color system for coloring plaster castings. Kit includes eight colors of pigment, mixing tray, foam applicator, and instructions.

E-Z WATER

This heat-activated water modeling product is clear, nearly colorless, nontoxic, low odor.

LIGHTWEIGHT HYDROCAL

A specially formulated plaster product for use in making plaster castings and hard shell. Half the weight of Hydrocal, yet dries to a tough surface which can be easily carved.

MOLD-A-SCENE PLASTER

Mix with water to form a workable plaster that is shaped like modeling clay. Dries to a hard plaster surface.

PLASTER CLOTH

The quick easy way to create a terrain shell on top of newspaper wad contours. Cut to desired size, dip in water, and place on the contours. Dries to a hard plaster surface.

LATEX RUBBER

Ready to use latex rubber for modelers who want to make their own rock molds.

FLEX PASTE

A specially formulated flexible modeling paste which will not crack as it dries. Excellent for finishing Styrofoam.

Tunnel Liner Form (C1250)

Earth Color Kit (C1215)

E-Z Water (C1206)

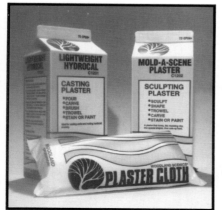

Lightweight Hydrocal (C1201), Mold-A-Scene Plaster (C1202), Plaster Cloth (C1203)

Latex Rubber (C1204)

Flex Paste (C1205)

ne Talus

Medium Talus

Coarse Talus

Extra Coarse Talus

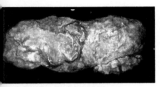

Washed Rock (C1242)

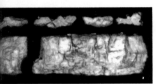

ase Rock (C1243)

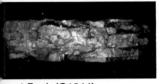

acet Rock (C1244)

TALUS (ROCK DEBRIS)

Talus is the rock debris that is seen almost everywhere near rocky areas, in and near water, and on top of tunnel portals and retaining walls. Model this feature with four colors and four sizes of lightweight Talus (Rock Debris) suitable for any scale. Mix the various sizes of Talus for the most realism. Select a color which most closely matches your rock areas or custom color your own Talus using the Natural color with the Earth Color Liquid Pigments.

ROCK MOLDS

The fifteen selections of Woodland Scenics Rock Molds give you the variety you need to create rocks for any area of the country, any type of terrain, and any scale. Use Lightweight Hydrocal to pour the rocks and create castings which can be carved easily with a hobby knife or dental pick. The Rock Molds are durable enough for any number of castings yet flexible enough to give you easy release of the Lightweight Hydrocal castings. The rocks you create with these molds are highly detailed for use by even the most demanding modeler.

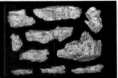

Outcroppings (C1230)

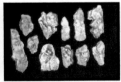

Surface Rock (C1231)

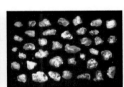

Boulders (C1232)

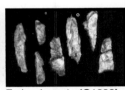

Embankments (C1233)

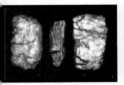

Random Rock (C1234)

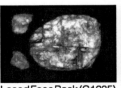

Laced Face Rock (C1235)

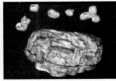

Classic Rock (C1236)

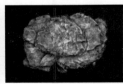

Wind Rock (C1237)

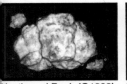

Weathered Rock (C1238)

Strata Stone (C1239)

Rock Mass (C1240)

Layered Rock (C1241)

137

RETAINING WALLS

High density plaster Retaining Walls come three to a package. Use as is or modify to create stepped walls and curved walls. Use alone or butted together for a longer wall. Four styles add variety and detail. The Retaining Walls match the Tunnel Portal styles.

CULVERTS

Easy to assemble Culverts can be used to detail terrain areas under railroad tracks and roads. Each package contains two Culverts for use on either side of the track or road.

TUNNEL PORTALS

Tunnel Portals are useful for finishing out tunnels wherever they occur on the layout. Available varieties fit any geographic area or time era. Select from single or double track width. Use alone or with the matching Retaining Walls.

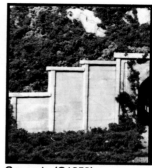

Concrete (C1258)

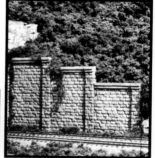

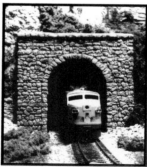

Concrete (C1262)

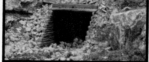

Timber (C1265)

Cut Stone (C1259)

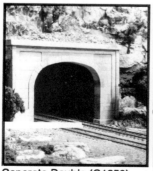

Random Stone (C1255)

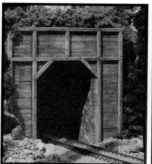

Timber Single (C1254)

Timber (C1260)

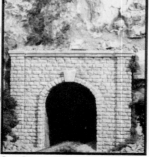

Concrete Double (C1256)

Cut Stone Single (C1253)

Random Stone (C1261)

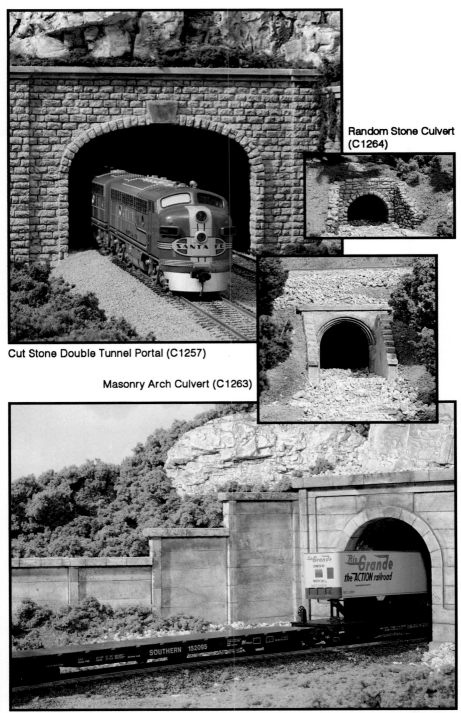

Cut Stone Double Tunnel Portal (C1257)

Random Stone Culvert (C1264)

Masonry Arch Culvert (C1263)

Concrete Single Tunnel Portal (C1252) with Concrete Retaining Walls (C1258)

SCENIC DETAILS®

The Scenic Details kits give you over 40 well-designed ways to add realistic detail to your HO layout. Each of the Scenic Details contains white metal castings which are highly detailed and ready to assemble and paint. Complete instructions are included as well as any Dry Transfers or other accessories which are needed. These kits are the easy and inexpensive way to add one building or vehicle, or a whole scene to your layout. The combinations are limited only by your imagination.

Street and Traffic Lights (D248)

Tank Truck (Diamond T) (D242)

Rocky's Tavern (D238), Ice House (D219), Grain Truck (1914 Diamond T) (D218)

Hyster Logging Cruiser and Tractor (D246)

These small town scenes are created from some of the items available in the Scenic Details line. In the photo above are the Branch Line Water Tower (D241), Grain Truck (D218), and Flag Depot (D239). Below: Scenic Details can be used in almost unlimited combinations to create both town and rural scenes. The Flat Bed & Tractor (D244), left, are parked in front of the Pharmacy (D221). Next door is the Ticket Office (D222). The Sign Painter (M105), from the Mini-Scenes, completes his work. On the right is the Gas Station (D223) and Vending Machine (D230) with the Tank Truck (D242) making a delivery.

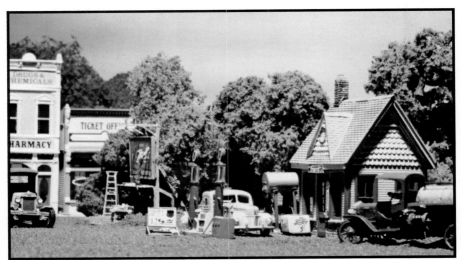

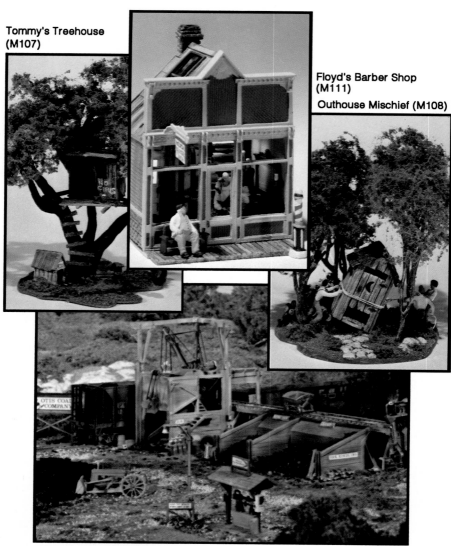

Tommy's Treehouse (M107)

Floyd's Barber Shop (M111)

Outhouse Mischief (M108)

Otis Coal Co. (TS153)

MINI-SCENES

The twelve individual Mini-Scenes include one building or other small scene to use on the railroad or as a separate display piece. All the intricate detail of the larger scenes is present, only they take up less room on the layout. Includes white metal castings plus detail items, Trees, Turf, and Foliage. Pictured above are three examples from 12 available Mini-Scenes.

COMPLETE SCENE KITS & TRACKSIDE SCENES

Designed for the modeler looking for fine quality craftsmanship, intricate detail, and authenticity. Each is a complete scene and includes the white metal castings, Turf, Foliage, and detail items needed to finish the scene. Otis Coal Co., pictured above, is one of several kits available.

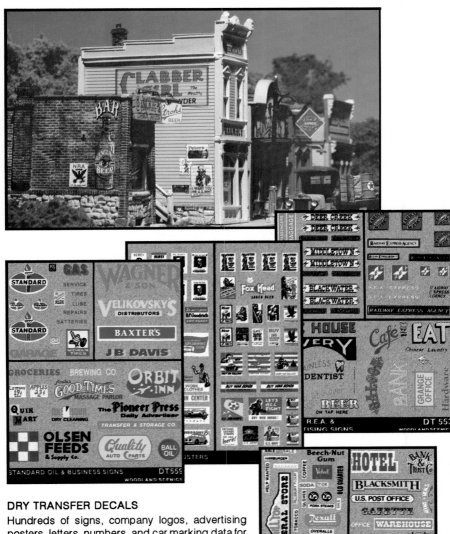

DRY TRANSFER DECALS

Hundreds of signs, company logos, advertising posters, letters, numbers, and car marking data for accurately detailing any facet of the railroad. Easy to use, even for beginners. Just place in desired position and rub gently with a burnisher or dull pencil. Will adhere to a smooth or textured surface leaving no unsightly film.

MODEL GRAPHICS

Includes a 64-sheet selection of dry transfer decals which contain 340 different alphabets, number sets, and line assortments to satisfy the expert craftsman.

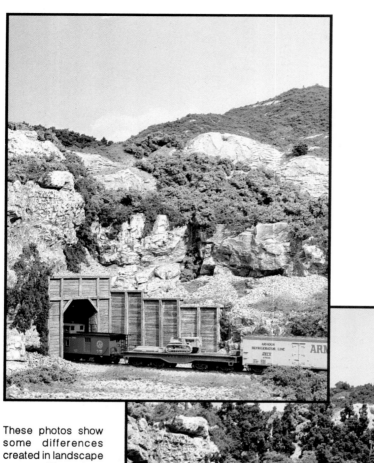

These photos show some differences created in landscape areas with various landscape products. Both photos show the same terrain area with rocks from the Rock Molds, the Timber Single Tunnel Portal (C1254), and Timber Retaining Walls (C1260). In the top photo, Clump-Foliage and Foliage Clusters are used to model the vegetation. The bottom photo has Ready Made Realistic Conifer Trees in various sizes.

TURF

Soil
T41

Burnt Grass
T44

Earth
T42

Green Grass
T45

Yellow Grass
T43

Weeds
T46

COARSE TURF

Earth
T60

Light Green
T63

Yellow Grass
T61

Medium Green
T64

Burnt Grass
T62

Dark Green
T65

EXTRA COARSE TURF

Yellow Grass
T34

Medium Green
T37

Burnt Grass
T35

Dark Green
T38

Light Green
T36

Conifer Green
T39

BLENDED TURF

Green Blend
T49

Earth Blend
T50

BALLAST

Iron Ore
B70

Lt. Gray
B74

Dark Brown
B71

Gray
B75

Brown
B72

Cinders
B76

Buff
B73

Coal
B92

GRAY BLEND BALLAST

Medium
B94

TALUS (ROCK DEBRIS)
EACH COLOR IS AVAILABLE IN FOUR GRADES: FINE, MEDIUM, COARSE AND EXTRA COARSE.

Natural
C1284

Gray
C1280

Buff
C1272

Brown
C1276

LICHEN

1½ QUART SIZE PACKAGE

Spring Green
L161

Dark Green
L164

Light Green
L162

Autumn Mix
L165

Medium Green
L163

Natural
L166

3 QUART SIZE PACKAGE

Light Green Mix
L167

Dark Green Mix
L168

EARTH COLOR LIQUID PIGMENT

White
C1216

Black
C1220

Concrete
C1217

Raw Umber
C1221

Stone Gray
C1218

Burnt Umber
C1222

Slate Gray
C1219

Yellow Ocher
C1223

Green Undercoat
C1228

Earth Undercoat
C1229

FOLIAGE

Light Green
F51

Medium Green
F52

Dark Green
F53

Conifer Green
F54

Early Fall
F55

Late Fall
F56

FIELD GRASS

Natural Straw
FG171

Harvest Gold
FG172

Light Green
FG173

Medium Green
FG174

REALISTIC TREES

Light Green

Medium Green

Dark Green

Conifer Green

Fall Mix

FOLIAGE CLUSTERS

Light Green
FC57

Medium Green
FC58

Dark Green
FC59

POLYFIBER

Green
FP178

146

GLOSSARY

(The first mention of each of these words in the text is italicized.)

Ballast: gravel or broken stone graded for size and laid in a railroad bed to give strength and stability to ties and rail, and allow for easy drainage of water. Compare to Talus.

Benchwork: the table, shelf, or legs underneath a model railroad that holds it up.

Blending: to combine at least two shades or sizes of something so that there is a color or size gradation but no exact border between the areas can be distinguished. Compare to Mixing.

Branch line: a railroad line off of the main line usually with less traffic than the main line.

Brick method: to face with precast rock castings placed side by side as in tiling. Compare to Shingle method.

Capillary action: the force, either attraction or repulsion, that is the result of adhesion, cohesion and surface tension in liquids which are in contact with solids. We use this force to allow thinned plaster or paint to flow into the depressions on a plaster casting.

Cellular Styrofoam: a dense foam material which is suitable for model contouring.

Cheesecloth: a very lightweight, unsized cotton gauze.

Clearance: the distance by which one object clears another, or the clear space between them, such as the space allowed around buildings and scenery items so that they do not interfere with the running of trains.

Craftsman: a person who creates or performs with skill or dexterity, especially in the manual arts. Generally recognized as the highest level of skill.

Culvert: a drain, sometimes including a tube or pipe, which allows water to pass under a road or railroad track.

Diorama: a scenic representation in which sculptured figures and lifelike details are displayed, usually in miniature.

Double track width: covering the distance across two parallel railroad tracks.

Dry brush: a technique of adding very little paint by brushing most of the paint off a brush before using it on the object you are painting. Dry brushing also refers to a Turf technique of using a dry brush to paint Fine Turf on landscape areas to add more color.

Flood-spray: to disperse water or other liquid by spraying in large enough quantity to soak an area thoroughly.

Flyspecking: a technique of adding specks of color to rock castings. Spray water on the casting. Bend a sheet of paper into an L-shape and place a small amount of Fine Turf on the horizontal section of the sheet. Puff air lightly on the vertical section to blow a small amount of the Turf onto the castings. Set with Scenic Cement when you like the result.

Gauge: the distance between the rails of a railroad track. Compare to Scale.

Homasote: a pressed paper product noted for its sound deadening and railroad spike holding qualities.

Hot wire: a tool used for cutting Styrofoam that melts the Styrofoam with a heated wire as it cuts.

Landscape: the plant and tree cover of an area. Compare to Terrain.

Lichen: a complex plant made up of algae and fungus growing together on a solid surface.

Lift-off panel: a section of a layout that is specially constructed so it can be removed for access to something below, yet when in place blends into its surroundings.

Leopard spot: to place spots of different colors in no particular pattern, as in the random spots on a leopard.

Mixing: to combine or merge into one mass. Compare to Blending.

Modular group: several people who agree to build modules to the same particular specifications so that the modules may be joined together for some purpose such as running model trains.

Module: a portable unit that is part of a total structure such as a model railroad.

Narrow gauge: a railroad with less than 4'-8½" between rails, frequently 3'. Compare to Standard gauge.

National Model Railroad Association: an organization of people interested in model railroading as a hobby, and of manufacturers and retailers of model

railroading equipment. For membership information, contact NMRA, Inc., 4121 Cromwell Rd., Chattanooga, TN 37421.

Operation: the practical application of principles or processes. In model railroading, the movement of trains in a prototypical manner.

Papier-mache: a molding material made with torn or shredded paper mixed with glue and other additives.

Peek-a-boo: an expression referring to the appearance and disappearance of model trains as they move through scenery and terrain areas.

Prototype: an original model from which something is patterned, a standard or typical example. In model railroading, actual full-size trains or real scenery.

Rail: a bar of rolled steel forming a track for wheeled vehicles. Compare to Track.

Rail yard: an area owned by a railroad where engines and rolling stock are fueled, serviced, and organized into trains going to different destinations.

Railroad premise: the establishment of certain ideas about a model railroad based on facts or assumptions made about time, geography, and identity of the railroad.

Roadbed: the area directly beneath the ties and rail of a railroad track.

Rolling stock: includes all of the freight and passenger cars used by a railroad.

Salt and pepper: a method of applying accent colors of Turf in a fine sprinkle. Begin with as little as possible and add as much as desired.

Scale: a proportion between two sets of dimensions, i.e., the proportion between the size of a model and the dimensions of a real train, building, person, or landscape feature. Compare to Gauge.

Scenic Sifter: a Woodland Scenics product consisting of a clear plastic bottle with two interchangeable snap-on shaker caps and a storage cap.

Scratchbuild: to build from the very beginning with raw materials, not using a kit.

Selective compression: the selection of a few items in an area to represent all the items from that area.

Shingle method: to lay out or arrange so as to overlap, as with Plaster Cloth or rock castings added to a layout. Compare to Brick method.

Single track width: covering the distance across one railroad track.

Spur: a rail line which services one or possibly two industries, usually owned by the industry.

Standard gauge: a railroad with 4'-8½" between rails. Compare to Narrow gauge.

Switch: a device usually made of two movable rails and the necessary connections designed to turn an engine and cars from one track to another. Also, a railroad siding. (Verb) moving cars to different positions within terminal areas.

Talus: rock debris found at the base of a mountain or cliff, or washed down the streams and rivers that form the drainage system for the area. Consists of random sizes which are not graded. Compare to Ballast.

Terrain: the physical features of a tract of land. Compare to Landscape.

Terrain shell: the firm coating, usually made of some type of plaster, placed on top of the terrain base of a model railroad or other model for the purpose of providing a smooth surface on which to paint, place buildings, and landscape materials. Also known as hardshell.

Texture: the visual surface characteristics or closely interwoven elements of something. Also the various sizes of items in an area such as landscape items on a layout.

Track: the parallel rails of a railroad which are gauged and control the movement of traffic. Compare to Rail.

View block: an item of scenery or structure that serves to prevent the viewer from seeing something behind it.

Weathering: the techniques of making buildings, engines, rolling stock, and vehicles look used rather than new.

Wet water: a solution made from one or two drops of liquid soap mixed with 6-oz. water.

INDEX

D

E

F

G

H